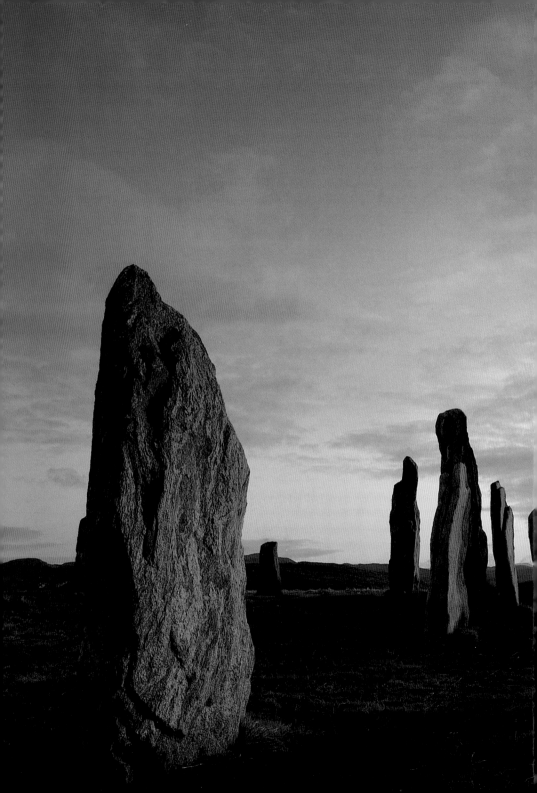

The pip travel photography guide to

Scotland

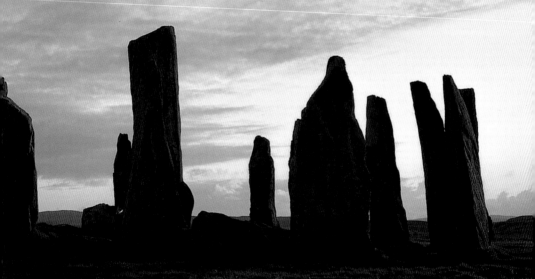

photographers'
pip
institute press

First published 2006 by

Photographers'
Institute Press / PIP

an imprint of
The Guild of Master
Craftsman Publications Ltd,
166 High Street, Lewes,
East Sussex BN7 1XU

ISBN 1 86108 487 0

Whilst every effort has been made to obtain permission
from the copyright holders for all material used in this
book, the publishers will be pleased to hear from anyone
who has not been appropriately acknowledged, and to make
the correction in future reprints.

The publishers can accept no legal responsibility for any
consequences arising from the application of information,
advice or instructions given in this publication.

British Cataloguing in Publication Data. A catalogue record of
this book is available from the British Library.

Production Manager: Hilary MacCallum
Managing Editor: Gerrie Purcell
Photography Books Editor: James Beattie
Editor: Virginia Brehaut
Managing Art Editor: Gilda Pacitti

Typeface: Meta Plus
Colour reproduction by Wyndeham Graphics
Printed by Hing Yip Printing Co Ltd

Contents

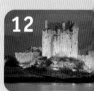
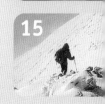

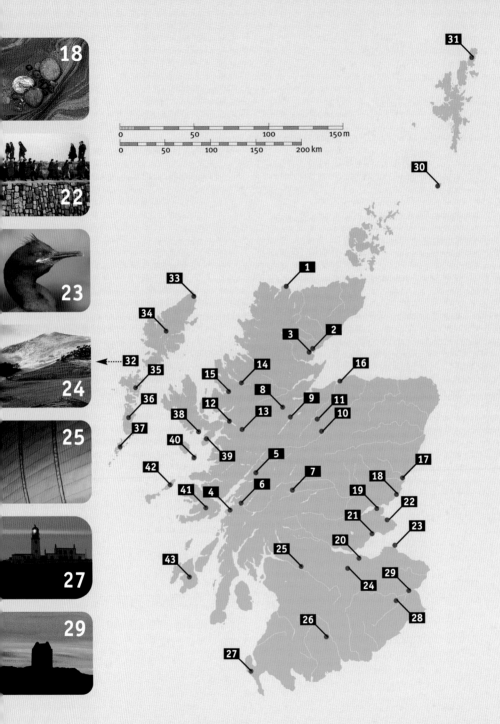

PART THREE **THE ISLANDS**

Foreword

You don't have to be Scottish to realize that Scotland is a country with a distinct national identity, some may say far removed from that of its overbearing southern neighbour and sometime foe. Indeed, Scotland has an abundance of universally recognized national symbols – bagpipes and kilts, whisky and thistle, haggis and oatcakes to name but a few – fixing itself into world consciousness out of all proportion to its size.

For landscape photographers, Scotland is a much favoured location with scenery that transfixes the viewer and instils in the first-time visitor a desire to return again and again. Ever since Queen Victoria made her first trip from the confines of the royal court to the mountain air of Deeside, this land of heather-clad peat moor and cold deep lochs, of glacier-cut glens and cloud-topped bens has drawn artists and photographers from all over the world, delighting in a scenery that is as distinctive as the accents of its inhabitants.

I remember my own first excursion to the Highlands, fresh and fit from a month-long trek into the Nepalese Himalayas where the mountain summits are of breath-taking and superlative-inducing heights. In terms of altitude, Scotland's peaks may be pimples by comparison, but their shape and form is no less dramatic. Surrounded on three sides by open seas, Scotland's ever-changing weather means the mountain and coastal scenery has a fickle character that makes it such a challenge (and a joy) to photograph.

The PIP Travel Photography Guide to Scotland is a compilation of articles and images originally published in *Outdoor Photography* magazine, produced by photographers who know the Scottish landscape better than anyone. Their atmospheric images and inside knowledge of each location will prove indispensable in helping you to plan your own excursion.

Of course, you don't have to be a photographer to enjoy this book, but you wouldn't want to visit any of the featured locations without a camera.

Keith Wilson
Editor, *Outdoor Photography*

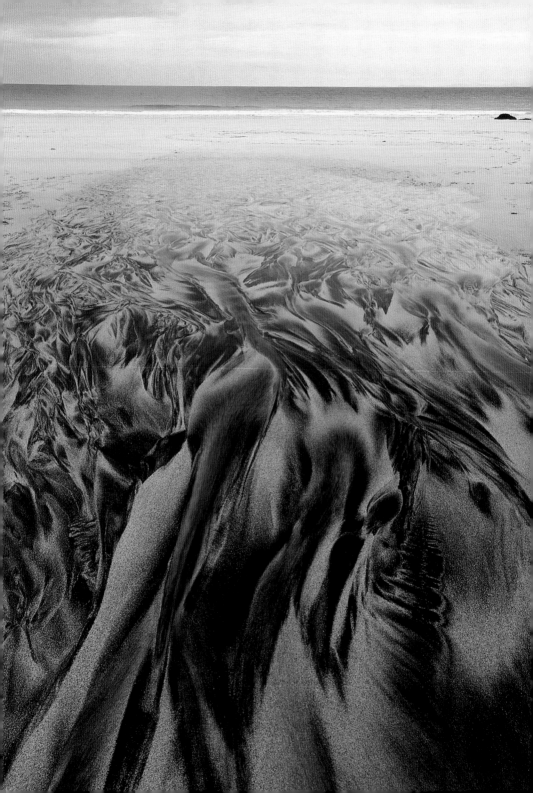

PART ONE THE HIGHLANDS

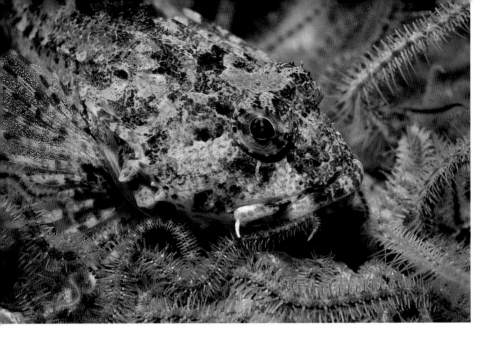

THE DRAMATIC CLIFFS OF WHITEN HEAD FORM A WELL-KNOWN
LANDMARK ON THE NORTH SUTHERLAND COAST, BUT THE
UNDERWATER SIGHTS ARE EQUALLY MESMERIZING **SUE SCOTT**

The stark pale cliffs of Whiten Head and its offshore stacks contrast dramatically with the dark moorland behind, while just to the south there are many mysterious sea caves. Underwater, the scenery is dramatic, with sheer walls, caves and arches, ending abruptly at 32–39ft (10–12m) deep in patches of white pebbles, tumbled smooth by violent seas.

In complete contrast to the bare-looking coastal cliffs, underwater the rocks (away from the scouring pebbles) are covered with an abundance of life. There are strong tidal currents on the north coast, especially where the water is squeezed between Orkney and the mainland, in the notorious Pentland Firth. The currents are not quite so extreme around Whiten Head, but still enough to bring plenty of food in the form of tiny planktonic creatures to the waiting arms and tentacles of filter-feeding animals. Sponges,

Above This long-spined sea scorpion (*Taurulus bubalis*) was hiding among brittlestars. Light from the flash has made its colours more obvious, especially the red eye, but underwater at this depth there is virtually no natural red light so it is almost invisible. *Nikon F50 in Sea & Sea housing with 60mm lens, exposure details not recorded, Velvia 50, Sea & Sea YS 50 and YS 30 flashes*

Whiten Head

sea squirts and anemones cover the rocks in a patchwork of colours and textures, while on less steep rocky reefs there are dense beds of countless thousands of brittlestars, covering the seabed.

With underwater photography I'm stuck with the set-up I jump in with – there's no changing lenses once you're in. For this dive I used a 60mm lens with main flash set above and slightly to one side of the subject, and a smaller fill-in flash set on slave mode on the other side, to help avoid hard shadows.

Brightly coloured animals are obvious subjects, but others take some searching for. Sea scorpions, see opposite page, have an amazing capacity to blend in with their background. They are so confident in their camouflage that they sit perfectly still, so you can get very close. Other marine animals can't move because they are fixed to the seabed, so they can be treated much as plants on land. You can find endless interesting compositions, colours and textures among the patchwork covering underwater rocks.

Below Brittlestar *Ophiothrix fragilis* on boring sponge *Cliona celata*. Boring sponges are quite interesting (called boring because they bore into shells!) and make a lovely background for this coloured brittlestar. *Nikon F50 in Sea & Sea housing with 60mm lens, exposure details not recorded, Velvia 50, Sea & Sea YS 50 and YS 30 flashes*

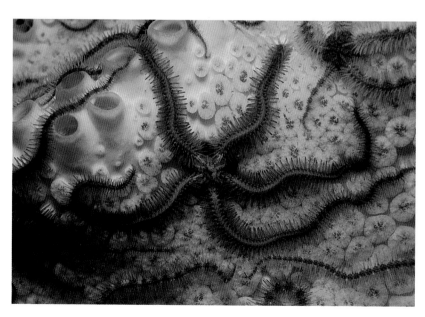

Whiten Head

Whiten Head is made of basal quartzite, a hard, pale rock which gives this dramatic headland its name. There is no road to the headland, but there are great views from the road between Durness and Sangobeg (if you can bear to look up from the beautiful sandy coves on this stretch of coast). The whole area is interesting geologically, with the long inlets of Kyle of Durness and Loch Eriboll carved out of bands of Durness limestone and basal quartzite sandwiched between older metamorphic rocks. Loch Eriboll is the only deep-sea loch on the north coast, and a good refuge from the prevailing south-westerly winds. Don't miss Smoo Cave, a cavern into which a stream pours, becoming a torrent after rain.

Below These anemones, *Sagartia elegans,* come in a range of colour varieties, this 'poached egg' version being quite common. They are nestling in a duvet of colonial seasquirts.
Nikon F50 in Sea & Sea housing with 60mm lens, exposure details not recorded, Velvia 50, Sea & Sea YS 50 and YS 30 flashes

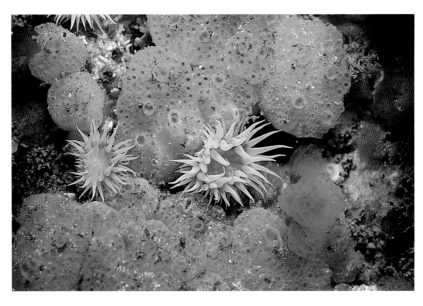

PLANNING

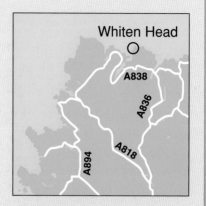

LOCATION
Whiten Head is on the north coast of Scotland, 6.2 miles (10km) east of Durness in Sutherland.

HOW TO GET THERE
By car; nearest stations with car hire are Inverness and Thurso. Nearest airport is Inverness. Boats can be launched at Portnancon on the west side of Loch Eriboll. We chartered an Orkney-based dive boat leaving from Scrabster.

WHERE TO STAY
We stayed in self-catering caravans at Laid, on the west side of Loch Eriboll. There is a wide range of accommodation in the Durness area, from inexpensive hostels and B&Bs to overpriced fishing hotels. It is wise to book in advance. For full listings contact the Scottish Tourist Board, details on page 190.

WHAT TO SHOOT
Abundant marine life and dramatic, unspoilt coastal scenery.

WHAT TO TAKE
It is wise to be prepared with clothing and equipment for all weather conditions.

BEST TIMES OF YEAR
The weather is unpredictable in summer when I have been there, but winter storms must be very dramatic to witness.

BEST TIMES OF DAY
Underwater – any time for close-ups, midday for wideangles. Above water – late afternoon or evening for the best light on the cliffs.

ORDNANCE SURVEY MAP
Landranger sheet 9

Loch Fleet

THIS NATIONAL NATURE RESERVE IN THE
NORTH-EAST HIGHLANDS OFFERS THE
VISITOR AN IMPRESSIVE DIVERSITY OF
WILDLIFE. FROM OSPREYS, PORPOISE
AND BUTTERFLIES TO RARE LICHENS
AND FUNGHI **NIALL BENVIE**

Below The sun eased
itself in, striking the
slopes of Carn Odhar.
I could see that the effect
was to be short-lived.
*Technical details
unavailable*

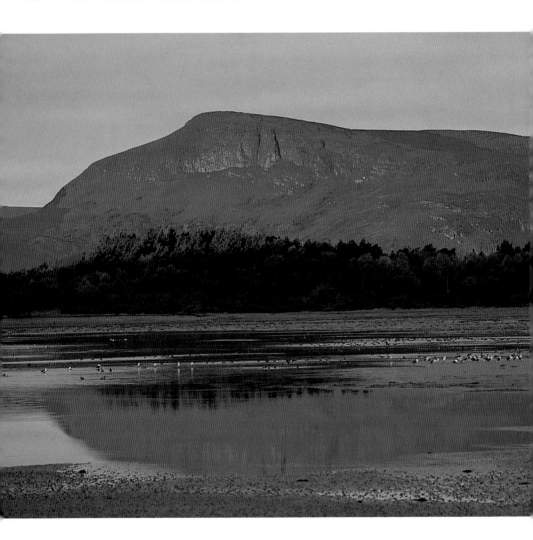

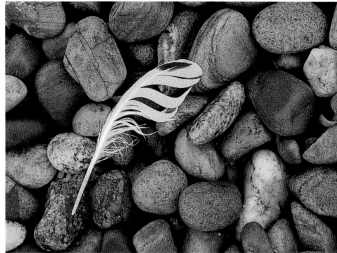

Right Gull feather.
I moved this feather into
position on the beach at
Littleferry to where the
stones were more
interesting colours.
*Nikon FE2 with
90mm lens, 1/4sec at
f/11, Velvia 50*

Like many photographers, I rarely shoot landscapes
unless they appear in the most full-bodied light of
dawn and dusk. But, while catching the evening light
involves nothing more than staying up, seeing in the
dawn calls for altogether more effort – and the
possibility of a wasted early rise. What's more, if the
air is damp, having cooled overnight, there will be
fewer dust particles than in the drier air of evening,
which means weaker reds. Sunsets, in theory, can
produce more vivid colours.

Loch Fleet National Nature Reserve in Sutherland
is one of those rare locations in eastern Scotland
where there is a chance to shoot a sunset across a
large tidal lagoon. Along with its pine woods,
rambling dunes, slacks and seaweed draped
foreshore, the area also boasts 168 classifications of
lichen flora, so there is plenty to photograph. Nearby,
a large alder swamp and wild Usnea-bearded hazel
wood add to the fascination of the area. The Scottish
Wildlife Trust's reserve, which is managed under
agreement with the owner, extends to 2,834 acres
(1,147ha), and access is generally unrestricted.

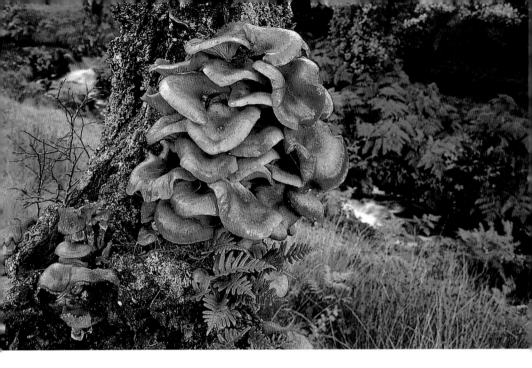

When I first visited, it was to see my first king eider. In those days, I stayed in a bed and breakfast, but when I returned a decade later, it was in a decrepit VW camper van. Discomfort aside, the van gave me a hitherto unprecedented freedom and the ability to be on location at just the right moment. For work in Scotland, my camper van remains an essential tool.

The evening's sunset was disappointing, but I hoped for better in the morning. However, when I peered outside at 6.30am the next day, there was a thick layer of cloud in the west. What I couldn't see was the break in the clouds on the eastern horizon. When I got up a short time after, the sun eased itself into the gap, striking the slopes of Carn Odhar. I was especially glad that I wasn't in a bed and breakfast this time because I could see that the effect was to be quite short-lived. I made the ramparts my midtone and I took a spotmeter reading off them, using a 180mm lens to frame the scene. So much for the better light belonging to the evening.

Above Velvet shank. Grey skies and heavy rain accompanied a visit to nearby hazel and birch woods, encouraging fungal growth. The gloomy lighting on the velvet shank in this shallow ravine was relieved by holding a silver reflector just out of frame.
Nikon F4 with 28mm lens, 1/2sec at f/11, Velvia 50

PLANNING

LOCATION
Loch Fleet lies to the east of the A9, just south of Golspie in Sutherland, about 50 miles (80.5km) or one hour north of Inverness.

HOW TO GET THERE
From the south, follow the signs for A9, Wick. Drive into Golspie and take the sharp turn to the right for the golf course, heading towards Littleferry. Balblair wood is the large, semi-natural pine forest on your right, along the north edge of the loch. The sand dune systems and open sea are at Littleferry.

WHERE TO STAY
There are listings of hotels and B&Bs at www.golspie.org.uk or contact the Scottish Tourist Board, details on page 190.

WHAT TO SHOOT
The tidal loch lends itself to panoramic treatment while the forest, home to some of Britain's rarest pinewood flowers, invites closer examination with a macro lens – in season. The inter-tidal zone is richly vegetated with seaweeds at all times of the year, but the birds which use the loch remain well away from the shore and rarely present opportunities for casual photography. The dunes and slacks are well populated with butterflies and moths in late summer. In winter, the principal interest is in landscapes, although the hazel woods near the Mound Alderwood NNR on the western side of the loch look their best during winter and early spring. These woods and the road down to Littleferry have good mushroom flora.

WHAT TO TAKE
Usual photographic equipment.

ORDNANCE SURVEY MAP
Landranger sheet 21

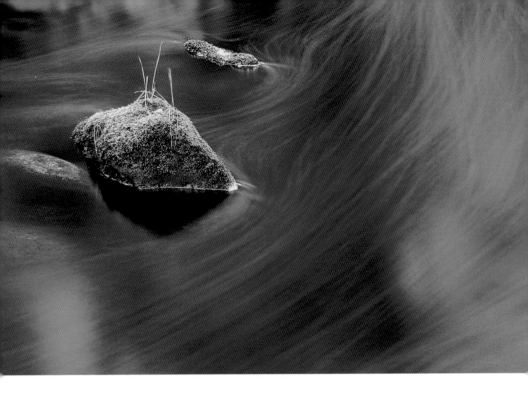

THIS WOODED GORGE NEAR THE HIGHLAND VILLAGE OF GOLSPIE HAS A LUSH DIVERSITY OF FERNS, MOSS AND LICHEN. VERY ATTRACTIVE AFTER A FRESH DOWNPOUR **ANDREW LINSCOTT**

Golspie Burn

You can travel to Golspie by road or rail – it is about an hour's drive north of Inverness on the A9. The village is roughly four hours north of Glasgow and Edinburgh. On this particular occasion, I headed to the locally known 'Big Burn'. It has a fabulous small river (or large stream) with one main waterfall. The Big Burn waterfall is located in a beautiful small gorge in Sutherland, and is only 20 minutes' walk from the north end of the village.

After heavy rainfall it's worth noting that a few other more interesting waterfalls appear, tumbling into the deep gorge. It's also very sheltered from the wind, making it an ideal location for photographing water and foliage. I'd been here once before after

Above This shot won a place as runner-up in the BBC *Countryfile* photo competition in 2002. *Canon EOS 1N with 28–105mm lens, 30secs at f/22, Velvia 50, tripod*

As well as using a
wideangle lens to
experiment with various
shutter speeds, it's also
worth bringing a fast
macro lens to make the
most of the lichen and
moss that thrives in the
area. The tree canopy
and the depth of the
gorge mean that light
availability can be a
limiting factor, so a
tripod is essential.

heavy rainfall and managed to get some interesting waterfall shots, but this time the rain had not been enough to create the intricate and delicate-looking falls. The main waterfall was in fairly full flow and looked pretty spectacular, but I decided to concentrate on the burn itself, looking for patterns and interesting foliage. Deep in the gorge there's a real wealth of plant life: trees, ferns and moss on the harsh rocky bank sides. There are so many different viewpoints in such a small area that you can easily spend hours exploring just a few yards.

I began by setting up a few shots, concentrating on the slower parts of the burn. At one point I noticed a moss-covered rock protruding from the water, which seemingly had just enough of a micro-environment to support a single grass plant. I also noticed a few bubbles that had been created further upstream by the waterfall, and they were moving slowly downstream. I didn't really know what I was going to get, and I'd not quite anticipated the artistic blur effect created by the bubbles.

Another feature of the Big Burn walk is the useful wooden bridges on which to perch your tripod, capturing views both upstream and downstream. By now the rain had stopped, with the light diffused by the cloud, and this was turning out to be a good day.

FACTS ABOUT:

Golspie

Golspie is probably best known for the fairytale-styled Dunrobin Castle situated just north. The castle provides additional photographic inspiration, and is the ancestral home of the first Duke of Sutherland. Towering above Ben Bhraggie, and looking down onto the village, the statue of the first Duke of Sutherland, known locally as the 'mannie', has become one of the best-known landmarks in the highlands.

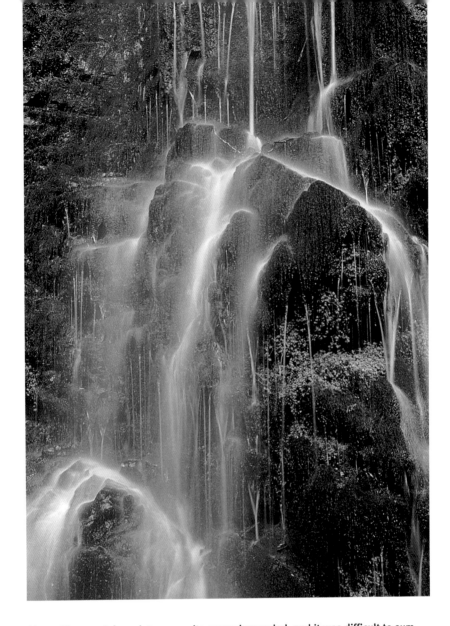

Above The area I drove into was quite sparsely wooded, and it was difficult to sum up the feeling of the place in a single shot, so I decided to concentrate on close-up details. All of this lichen is a good indicator of how clean the air is.

Canon EOS 1N with 28–105mm lens, 1/60sec at f/5.6, Velvia 50, tripod

PLANNING

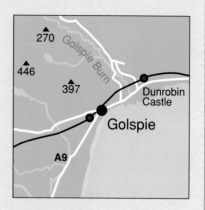

LOCATION
Big Burn is located on the northern edge of Golspie on the north-east coast of Sutherland.

HOW TO GET THERE
Golspie lies about 50 miles (80.5km) north of Inverness on the A9. For the Big Burn, park either in the car park by the Sutherland Arms just before leaving Golspie, or continue north on the A9 for a short time, taking a left turn signposted 'The Big Burn'. Follow this until you reach the car park. Golspie also has a train station.

WHERE TO STAY
The Sutherland Arms Hotel is well recommended, tel: +44 (0) 1408 633234, www.sutherlandarmshotel.com. Alternatively, for further information, visit www.golspie.org.uk, or contact the Scottish Tourist Board, details on page 190.

WHAT TO SHOOT
Waterfalls and streams leading to the beach, grey seals can often be found on local beaches, and inland red deer populate the surrounding hills, Dunrobin Castle.

WHAT TO TAKE
Wideangle lenses are essential, with a high-speed macro to make the most of the small details.

BEST TIMES OF YEAR
Any time of year – but the colours are beautiful after a downpour.

ORDNANCE SURVEY MAP
Landranger sheet 17

Oban

THE GAELIC FOR 'LITTLE BAY', OBAN IS KNOWN AS THE GATEWAY TO THE WESTERN ISLES – BUT THE VISTAS OF MOUNTAINS AND LOCHS MAKE IT WORTH LINGERING HERE **DENNIS HARDLEY**

Oban is one of the most picturesque places to visit in Scotland, made more so by its wide bay and views towards the islands. The viewpoint from which the main picture (right) was taken is on Oban Hill where the old hydropathic ruins are situated. To get there, turn up Stevenson Street which is off the main George Street, then follow Rockfield Road to its highest point and on the right is a row of three houses with a dirt track in front of them. This leads to the hydro ruins, from here you have to find your own way across grassy, boggy ground until you obtain this view looking down onto Argyll Square. Great care must be taken on this clifftop, especially at night, so I recommend you take a torch, as well as boots and warm clothes. But don't attempt this until you have made a daytime visit to acquaint yourself with the layout of the various paths.

For best results take the picture shortly before it's completely dark. I like to paint colour on night shots so I deliberately chose a small aperture to lengthen the exposure time. During such a long exposure, light from the head and tail-lights of cars is captured, adding colour and more impact to the scene.

For metering, I usually take both average and spot readings at a one second shutter speed. I can then calculate which aperture will give me a 10 to 30 seconds exposure time. If there are no moving lights, then I could choose a faster film with a shorter exposure as a result. No filter was used for the main picture because there was a natural sunset afterglow in the sky, but I do sometimes use a graduated pink or coral filter to add warmth to cold night scenes.

Below I like to paint colour on night shots, so chose a small aperture. *Mamiya RZ67 with 90mm lens, 20secs at f/16, Velvia 50, tripod*

Right Don't be afraid of experimenting – this unusual view was taken from within the tower at night with daylight film, using a standard lens. I stopped down to f/32 to create a natural starburst effect from the light. *Mamiya RZ67 with 75mm lens, 12secs at f/32, Velvia 50, tripod*

Oban

Oban is finely set in surroundings of great beauty. Apart from tourism, on which it heavily relies, other major industries are forestry, fishing and farming. Many pictures of Oban include the circular granite McCaig's Tower, named after the banker John Stuart McCaig. From this landmark a great panoramic vista of Oban and the islands can be seen – on a good day this has to be one of the best views in Britain.

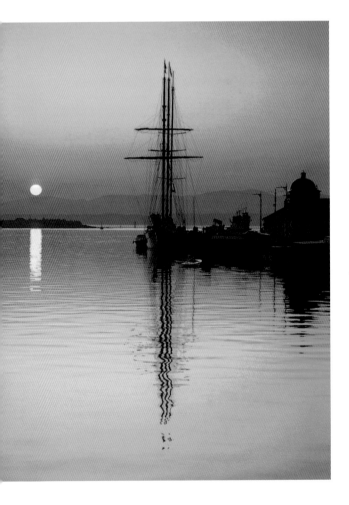

Left Wonderful sunsets usually happen when you least expect it. This shot of the training ship *Malcolm Miller* was taken from the seafront in the town centre with standard lens looking towards the north pier. It was shot around 10pm in midsummer, helped by still water and a high tide which gives the boat more height.
Mamiya RZ67 with 75mm lens, 1/30sec at f/11, Velvia 50

PLANNING

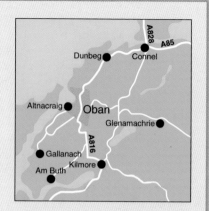

LOCATION
Oban is on the west coast of Argyll, approximately 100 miles (161km) north-west of Glasgow.

HOW TO GET THERE
By car from Glasgow, take the M8 west then turn off at Junction 30 to Erskine Bridge (toll), and on to the A82. At Crianlarich take the A85 west through Tyndrum, Loch Awe and on to Oban. The West Highland line from Glasgow runs daily services to Oban.

WHERE TO STAY
Go to www.oban.org.uk, telephone the Oban Tourist Information centre on +44 (0) 1631 563122 or contact the Scottish Tourist Board, details on page 190.

WHAT TO SHOOT
Take plenty of film, as Oban and its environs offers a lot for the photographer. The bay, from McCaig's Tower, is the obvious vantage point, but also try Pulpit Hill for the view of the bay and islands, especially in the late afternoon and at sunset. In the morning the ruins of Dunollie Castle are worth seeing.

WHAT TO TAKE
For night shots a sturdy tripod, flashlight, cable release, boots, daylight film, wideangle, standard and telephoto lenses. Oban has specialist camera shops, so you should have no problem restocking with film, batteries and filters.

BEST TIMES OF YEAR
All year round, but spring and autumn offer the better light. Christmas and any snowfall is also special.

ORDNANCE SURVEY MAP
Landranger sheet 49

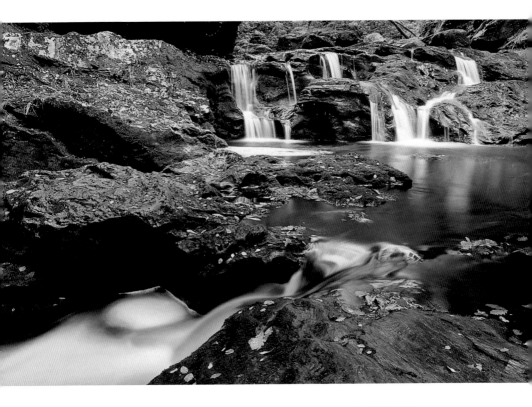

INVERSNAID IS SITUATED ON THE NORTH-EAST BANKS OF LOCH LOMOND, A WORLD-FAMOUS AREA STEEPED IN FOLKLORE, LEGEND AND HISTORY **PHILIP HAWKINS**

There is only one road to Inversnaid, which is not only picturesque, but also rich in history. Sir Walter Scott regularly travelled the route and many of his writings were inspired by the surrounding countryside whilst the notorious outlaw Rob Roy was born and raised in the area.

Inversnaid is located on the north-east banks of Loch Lomond. The photographic opportunities at Inversnaid are plentiful. Walk alongside the renowned 'bonnie banks' or follow the trail through the nature reserve if you prefer wildlife photography.

Above Having chosen a low viewpoint on a rock near the centre of the river, it was almost impossible to look through the viewfinder. Eventually I managed it but got wet in the process! *Canon EOS 50E with 28–70mm lens, several secs at f/16, Velvia 50*

Inversnaid

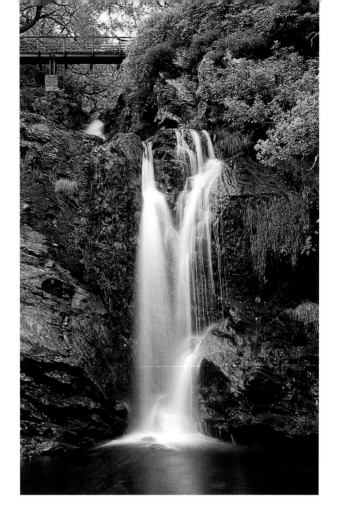

Right This was the first shot of the day, taken adjacent to the car park just behind the pier. A slow film, overcast conditions and small aperture meant a lovely long shutter speed – just the job for a waterfall. *Canon EOS 5OE with 28–70mm lens, several secs at f/16, Velvia 50*

Inversnaid

Loch Lomond is Britain's largest body of fresh water and at Inversnaid it is the third deepest. The Inversnaid nature reserve lies on a quiet section of the famous West Highland Way, close to the foot of Ben Lomond, Scotland's most southerly Munro. In the early 18th century Rob Roy MacGregor was evicted from his farm at Inversnaid and unfairly outlawed by the Duke of Montrose. Many of his haunts and hide-outs can still be discovered in the area. Inversnaid is part of the Loch Lomond and Trossachs National Park.

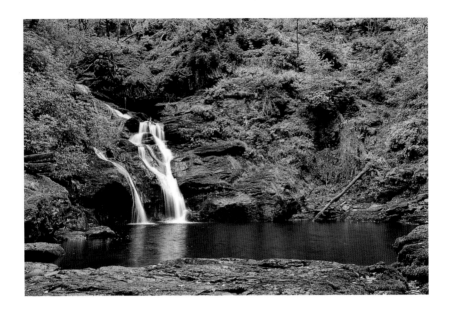

Above Initially I was going to place the waterfall bang in the middle of the frame until I spotted the fallen log in the background. I decided, instead, to put the falls on the left-hand side and include a bit of the rocky slab in the foreground.
Canon EOS 50E with 28–70mm lens, several secs at f/16, Velvia 50

I decided to follow the river that runs down from Loch Arklet and plunges into Loch Lomond at Inversnaid. A footpath climbs up beside the Inversnaid waterfall and leads off into the wood. I headed into the forest knowing that the foliage was going to be dense enough to enable me to omit the poor sky from my pictures.

For the main picture, I chose a low viewpoint, clambering over a few rocks to find a position close to the middle of the river. This allowed me to place a cluster of rocks in the bottom right-hand corner of the frame with the waters flowing past.

In order to keep everything sharp, I had pre-set the camera to f/16 with aperture priority mode. The overcast day meant slow shutter speeds, which I was happy with as I love the ethereal effect this gives to fast-flowing water.

I continued following the river upstream, pausing at different vantage points along the way. The trail itself is not strenuous, but care must be taken as the rocks can be slippery, especially the large boulders.

PLANNING

LOCATION
Inversnaid is located on the north-east banks of Loch Lomond.

HOW TO GET THERE
Inversnaid is 16 miles (25.7km) from Aberfoyle and the only road to it is the B829. Follow this through the hamlet of Kinlochard until reaching Loch Arklet. Turn left at the junction and it is approximately 2 miles (3.2km) further along.

WHERE TO STAY
I recommend Altskeith Country House B&B, tel: +44 (0) 1877 387266, www.altskeith.com. Or contact the Scottish Tourist Board, details on page 190.

WHAT TO SHOOT
Superb landscapes; Loch Chon, Loch Ard and Loch Arklet lie between Aberfoyle and Inversnaid. Wildlife in the RSPB reserve. Waterfalls, rivers and mountains.

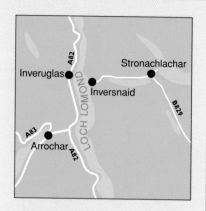

WHAT TO TAKE
Wideangle lenses for landscapes and telephotos for wildlife. Warm-up and polarizing filters can be handy. Decent boots for walking through the forest are essential and a tripod if you intend using slow shutter speeds for photographing the waters.

BEST TIMES OF YEAR
Anytime except when it is snowing in winter. The road can sometimes be difficult if you don't have four-wheel drive.

ORDNANCE SURVEY MAP
Landranger sheet 56

SHELTERED BY SOME OF SCOTLAND'S MOST SPECTACULAR MOUNTAINS, LOCH ETIVE OFFERS MIRROR-CALM WATERS AND VIVID REFLECTIONS **GUY EDWARDES**

Concealed among some of Scotland's most impressive and photogenic mountain scenery, Loch Etive is one of Britain's most beautiful bodies of water. Distinctive summits tower over the loch as it cuts inland towards Glen Coe. The imposing twin peaks of Buachaille Etive Mor and Buachaille Etive Beag dominate the view north through Glen Etive, where the river cuts a seemingly ever-changing course as it powers along the floor of the glen. The glacial action, which originally formed this steep-sided valley and the actual loch itself, is clearly evident along its generous 17-mile (27.4km) length. The loch itself is sheltered along much of its length by the surrounding hills, so its waters often provide perfect reflections at either end of the day.

On this occasion I made my way down the long winding road from Glen Coe, past numerous potential photographs where pockets of hoar frost clung to every branch. When I arrived at the head of the loch, late in the afternoon, the sky was clear and blue, however, within half an hour broken cloud began to appear from the east and soon covered the sky above me. It was now just before sunset and the last rays of sunlight began to add a little subtle colour to the encroaching clouds. Fortunately the air was still and the surface of the loch was perfectly calm, providing a mirror image of the colourful patterned sky above. Although the loch was frozen over, a thin film of water on top of the ice provided a mirror-like surface. I began shooting close to the ruined pier and found a position from which I could fill the foreground with rich, colourful reflections.

Below As the sun dipped gently below the horizon the clouds thickened and began to take on more intense tones of pink and red. For this shot I took a spotmeter reading from the brightest section of sky close to the horizon using my Canon EOS 3. I opened up 1⅔ stops so that it would record as a very light tone. Then I transferred this reading to my XPan.
Hasselblad XPan with 90mm lens, 4secs at f/22, Velvia 50, tripod

Loch Etive

Loch Etive is 17 miles (27.4km) long and, although tidal, this fjord-like loch is almost land-locked. Just before the loch empties into the Firth of Lorne at Connel it passes through a narrow channel, forming the Falls of Lora (Europe's only seawater falls) at Connel Bridge, every time the tide recedes. A colony of seals has made its home in the loch and they can often be seen basking on rocks in the inlets between Connel and Taynuilt. Footpaths lead along either side, providing a circular trail along the loch's wild shores.

With the contrast range now much reduced, which would enable me to record sufficient detail in the dark hillsides at either side of the loch, I decided to switch to panoramic format, this enabled me to concentrate on the most colourful section of the scene without including too much of the dark mountain slopes.

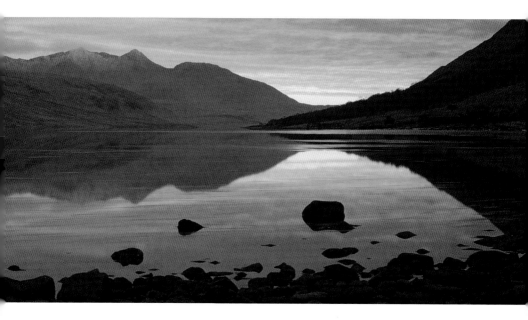

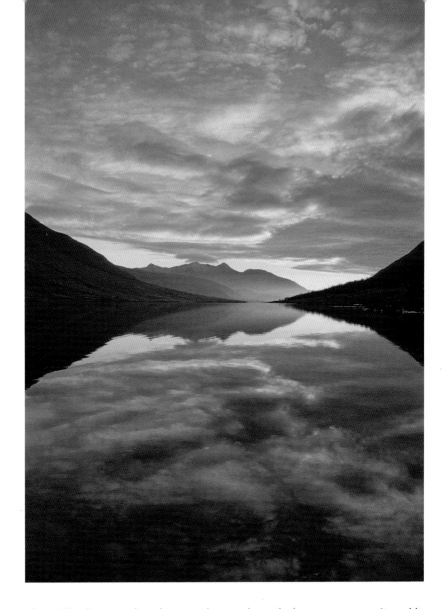

Above This shot was taken about 40 minutes prior to the image on page 33. It would have been impossible to capture all of the detail on colour slide film without the help of a neutral density graduated filter. I used a 2-stop hard-edged filter here, with the transition line directly on the distant horizon. When shooting reflections, the image in the reflection should never appear brighter than its source.

Canon EOS 3 with 24mm lens, 1sec at f/16, Velvia 50, 2-stop neutral-density graduated filter, polarizer, tripod

PLANNING

LOCATION
Loch Etive lies in Argyll, Scotland.

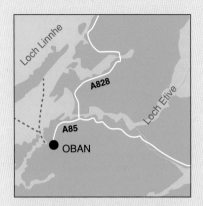

HOW TO GET THERE
The head of Loch Etive can be reached by car via a narrow road which runs through the spectacular Glen Etive, which leads from Glen Coe. There is limited parking at the head of the loch where a ruined pier leads into the water.

WHERE TO STAY
Kingshouse Hotel, Glencoe, tel: +44 (0) 1855 851259, www.kingy.com, is recommended. For other options contact the Scottish Tourist Board, details on page 190.

WHAT TO SHOOT
Sunsets, reflections and mountains. Seals, deer, golden eagles and other wildlife can be viewed from a boat that offers cruises up and down the loch.

WHAT TO TAKE
The narrow steep-sided nature of the glen means that a wideangle lens is a must – about 16–24mm in 35mm format. Film users will find neutral-density graduated filters vital in order to control contrast, whereas digital shooters should consider making two exposures (one for the shadow areas and one for the highlights) and combining them in Photoshop.

BEST TIMES OF YEAR
Autumn is spectacular in Glen Etive when the birches reach peak colour. Spring is good for landscape photography, especially when there is snow on the mountaintops. There can be good light throughout the day from autumn to spring but late afternoon and early evening provide the best opportunities at the head of the loch.

ORDNANCE SURVEY MAP
Landranger sheets 49 and 50

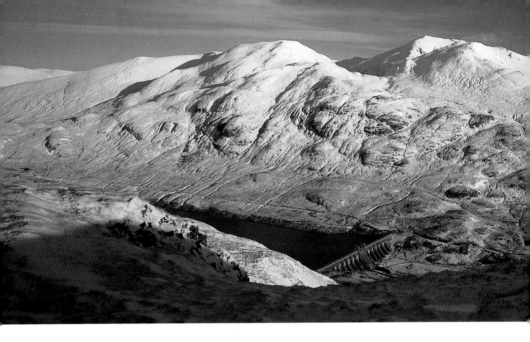

EXPECT PRISTINE AND SPARKLING
MOUNTAIN LANDSCAPES AT TARMACHAN
RIDGE, WITH VISTAS EXTENDING TO BEN
NEVIS AND BEYOND **HARRY HALL**

Leaden clouds were being driven across the sky as we donned our boots, ready to leave the warmth of the fireside and head for Tarmachan Ridge in Perthshire. The weather forecast, however, promised high pressure and clear skies. Later, as we trudged through a dusting of freshly fallen snow, steadily climbing towards the clouds, the ceiling of grey began to retreat, revealing the peaks around us. It was developing into one of those rare, magical mountain days. The cloud had cleared to reveal Ben Lawers resplendent in a cloak of fresh snow. In the valley below was Lochan na Larige, its indigo blue water retained by a dam built in the 1950s.

The summit of Meall nan Tarmachan forms the east end of a 1.8 mile (3km) ridge, known as the Tarmachan Ridge – a sea of white-capped peaks,

Above From a saddle on the ridge up to Meall nan Tarmachan the land drops away steeply to the shores of Lochan na Larige. Dwarfing the lochan is the massif of Ben Lawers and Beinn Ghlas.
Hasselblad XPan with 45mm lens, 1/250sec at f/5.6, Provia 100F

Tarmachan Ridge

standing sturdy and proud against the blue sky. Looking north-west I could recognize the impressive dome of Ben Nevis some distance away. Fresh snow had been sculpted by the wind to form a series of abstract shapes over the rocks. Careful not to get my footprints in the way of the picture, I used these snow sculptures to form the foreground to shots looking along the ridge and north to Garbh Meall.

Below Snow-blown sculptures form on the rocks of the summit plateau of Meall nan Tarmachan, looking north across Glen Lyon and Meall Buidhe to a sea of peaks stretching away to the west of Scotland. I used a polarizing filter to darken the sky. *Hasselblad XPan with 45mm lens, 1/250sec at f/5.6, Provia 100F, polarizer*

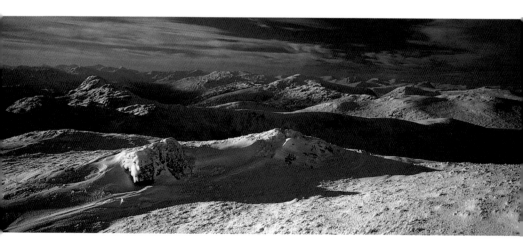

Exposures for snow scenes are always tricky to get right, because a meter reading from the snow will underexpose the image leaving the snow looking grey, but giving a correctly exposed sky. Over-exposing by one stop results in good snow tones, but washy, weak skies. This can be darkened with judicious use of a polarizing filter, but too much filtration will result in overly dark skies. I have found a quick method to get good exposure for snow scenes – an incidental light reading taken off a bright red glove seems to produce white snow without burning out detail.

Our progress along the ridge had been slowed by the many picture stops we had made, so by the time we reached the end of the ridge the sun was sinking into the southern sky, its rays reflecting a warm, orange glow. With a few minutes before sunset I began to hunt for a vantage point from which to photograph Ben Lawers. In the failing light we still had to get to the car from the 3,005ft (916m) peak as darkness fell over the harsh and unforgiving winter landscape. It had been a magical day of photography.

Tarmachan Ridge

Tarmachan Ridge was bought by the National Trust for Scotland in 1996 and became part of the Ben Lawers National Nature Reserve. The Iron Age saw the first settlers move into the area; they began subsistence farming and formed small communities. Their descendants eked out a living until the Highland Clearances during the 18th and 19th centuries drove the crofters from the land to make space for sheep farming. The first recorded skiing in Scotland took place on the slopes of Ben Lawers, Beinn Ghlas, and Meall nan Tarmachan. From their location in the centre of mainland Scotland it is possible to see both the east and west coast from the summits of Meall nan Tarmachan and Ben Lawers.

PLANNING

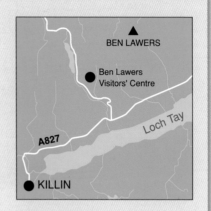

LOCATION
Tarmachan Ridge, part of Ben Lawers National Nature Reserve, overlooks the village of Killin in Perthshire.

HOW TO GET THERE
Follow the A827 north from Killin for 4.3 miles (7km). A minor road on the right leads to the car park at Ben Lawers Visitors' Centre.

WHERE TO STAY
Killin has accommodation to suit every pocket – from a campsite and a youth hostel, to country hotels. The local Tourist Information centre can be located at www.killin.net or tel: +44 (0) 1567 820254. For further listings contact the Scottish Tourist Board, details on page 190.

WHAT TO SHOOT
Dramatic highland landscapes and disused settlements. The nature reserve supports populations of red deer, ptarmigan, red grouse, dipper, ring ouzels and curlew.

WHAT TO TAKE
Keep photography gear light as the slopes are steep and you will have to carry your survival gear and warm waterproof clothing. In winter, ice axe and crampons are needed.

BEST TIMES OF YEAR
Between June and August is the best time to see alpine plants. Spectacular snowscapes in winter, but take care when walking. Contact the mountain visitor centre for advice, tel: +44 (0) 1567 820397.

ORDNANCE SURVEY MAP
Landranger sheet 51

Glen Affric

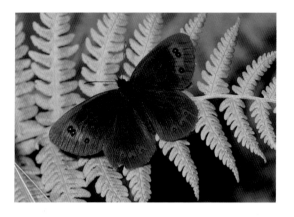

THIS NATIONAL NATURE RESERVE NEAR
INVERNESS IS RENOWNED FOR ITS NATIVE
PINE WOODLAND, VARIED WILDLIFE AND
EXCELLENT TROUT FISHING **NIALL BENVIE**

Left Scotch argus butterfly. Shooting butterflies demands mobility. Often there is no option but to hand-hold the camera. If you use flash to light the picture, hold it as close as possible for open, feathered shadows. *Nikon F4 with 180mm lens and 52.5mm extension tube, 1/250sec at f/11, Velvia 50, SB25 flash*

G len Affric is one of the most picturesque glens in Scotland. It has old pine trees, impressive mountains and expansive lochs – but can also be a frustrating place to photograph. Many good viewpoints are marred by powerlines or other signs of human activity that diminish the sense of wilderness. Nevertheless, with a little searching, the glen yields beautiful images at any time of year.

Cool summer mornings in the Highlands mean that the midges will be inactive and if the sky is clear there is a good chance of a misty dawn. I was aware of the coolness of the day as soon as my alarm woke me at 3.30am and a glance at the blue-black sky above suggested that I'd see the sun that morning. Owing to the orientation of the glen, it is possible in summer to shoot the loch at first light as the sun is not blocked by mountains.

The visual experience of Glen Affric, especially in good light, can be overwhelming and the photographer is challenged to find elements within the grand scene

Right This composition is about the natural forest in its loch-side setting so I excluded reference to any boundaries and scale. *Nikon F4 with 180mm lens, exposure details not recorded, Velvia 50*

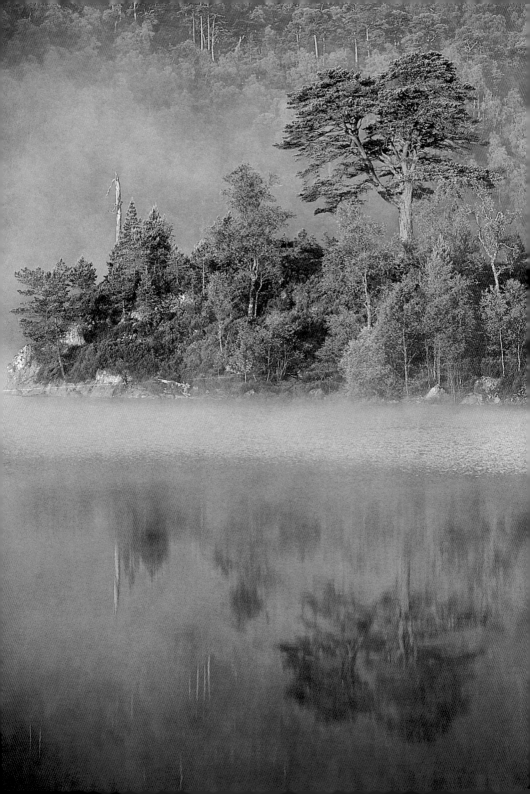

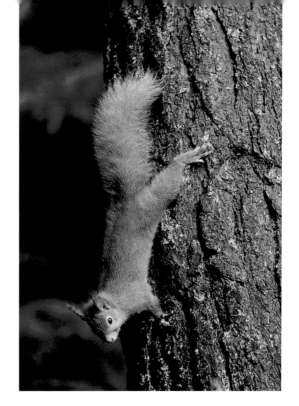

Right Old pinewoods are a stronghold of the red squirrel but you'll have to be quick to catch one on camera. Your best hope is to encounter an animal which has come to search for food on the forest floor. Keep your camera and lens mounted on the tripod ready for action. If you want to use fill-in flash to brighten the scene, hold it off-camera to avoid 'eye-shine'.
Nikon F4 with 300mm lens, 1/60sec at f/2.8, Velvia 50 rated at ISO 100

which encapsulate its character. The composition I settled for is explicitly about the natural forest in its loch-side setting. I wanted to hint that the pine forest is extensive by excluding reference to any boundaries, or being clear about scale. Had I included the skyline, bare of trees, this suggestion would have been lost. A 180mm lens gave me the framing I needed and allowed me to shoot from far enough away to foreshorten perspective and make the forest on the other side of the loch appear closer.

Landscape photography is not a leisurely pursuit. At the ends of the day when the light changes from minute to minute it is essential to identify the locations you want to shoot in advance. There is no time to be hunting around once the sun is up. There are a number of other good locations along the side of Loch Beinn al Mheadhoin, but some of them involve a bit of a climb.

PLANNING

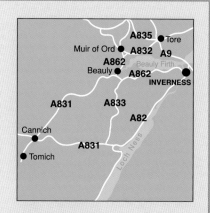

LOCATION
Glen Affric starts about 28 miles (45km) south-west of Inverness, near the village of Cannich.

HOW TO GET THERE
By car, avoid Inverness by following the A9 as far as the Tore roundabout (watch out for red kites here). There, take the A832 to join the A862 for Beauly. Follow the A831 to Cannich. Go straight through the village, heading for Tomich then branch right at the power station. There are three main parking areas in the glen, but early in the morning you can get away with using some of the larger passing places.

WHERE TO STAY
In Tomich. Kerrow House, tel: +44 (0) 1456 415243, www.kerrow-house. co.uk, provides good B&B in an elegant setting. If you want to stay in Glen Cannich, the Mullardoch House Hotel tel: +44 (0) 1456 415460, offers a bit of luxury.
For further information contact the Scottish Tourist Boad, details on page 190.

WHAT TO SHOOT
Get out early and late for dramatic scenics, but also look out for red deer, buzzards, frogs and squirrels.

WHAT TO TAKE
Midges are rampant in summer, especially in damp places which are sheltered from the wind. Insect repellents containing DEET are effective, but ruin film and contact lenses so you may want to try a midge net instead. Those for mosquitoes are usually ineffective.

BEST TIMES OF YEAR
The heather brings a welcome splash of colour in August then birch and bracken set the glen alight in late September.

ORDNANCE SURVEY MAP
Landranger sheets 25 and 26

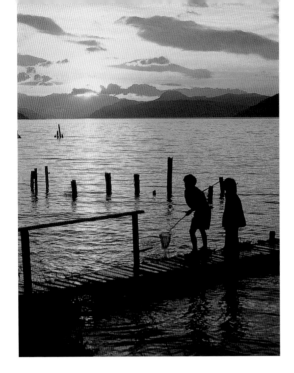

Left Be prepared to act fast and change lenses if necessary, to capture any action that occurs, such as ducks swimming or kids playing by the water. Here some boys were trying their luck with a fishing net for sticklebacks.
Ricoh XR-X with Tokina 28–70mm lens, 1/45sec at f/9.5, Velvia 50

LOCH NESS IS ONE OF THE MOST PHOTOGRAPHED AND VISITED DESTINATIONS IN SCOTLAND, BUT THERE IS MORE TO DISCOVER HERE THAN JUST THE ELUSIVE MONSTER **STEVE AUSTIN**

It's worth a visit to Loch Ness on an evening near the shortest day, because this is the only time of year when the sun sets far enough round to the south-west to be seen setting down the full length of the loch. And this, combined with the fact that Loch Ness never freezes, gives a rare opportunity for sunset pictures, with reflections, and silhouettes.

All you need is a little settled weather in the two weeks either side of the shortest day, ideally with calm conditions and a scattering of clouds. The weather can quickly change as dusk approaches (mid- afternoon up here – so be prepared). The best viewpoint is from Dores, on the south shore. Position yourself so that you are looking over Dores Bay and down the length of the loch.

Bring a selection of lenses, such as a 28–70mm zoom, plus another zoom going up to 200 or 300mm for close-ups of the distant hills and sky. If using film, use a slow one with good colour saturation to boost the colours. Remember to stop well down, for maximum depth of field, especially when using telephoto lenses. A warm-up filter can be useful if the sky is a little pale, and also a neutral-density graduated filter if the contrast between the sky and the water is high. To avoid flare when shooting directly into the sun, make sure the sun is diffused by cloud or partly hidden behind a hill. And after it has set, you have about 30 minutes of useful light to capture the changing colours before they fade away.

Below The 30 minutes of light after the sun has set gives a variety of changing colours and the old pier posts in the water can be used for foreground interest. The fish cages can just be seen in the left of the picture.
Ricoh XR-X with Tokina 28–70mm lens, 1/2sec at f/13, Velvia 50

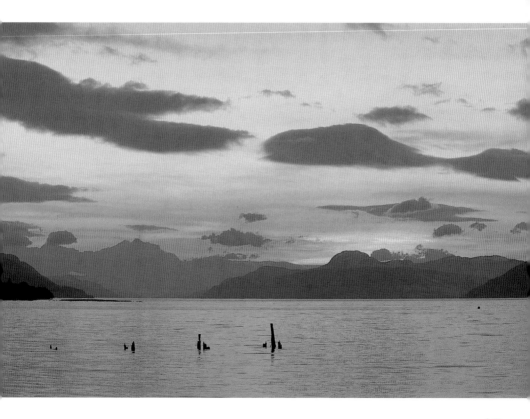

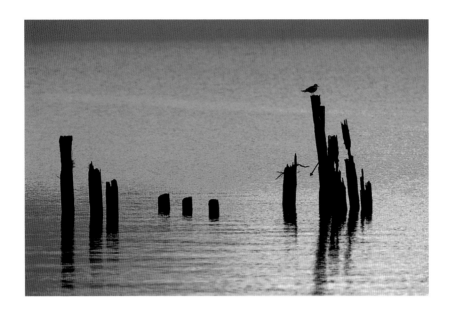

Above Use a telephoto zoom to crop tightly on parts, such as patches of rich colour or interesting cloud. *Ricoh XR-X with Tamron 80–210mm lens, 1/30sec at f/8, Provia 100, tripod*

Loch Ness

One of the world's most famous stretches of water, Loch Ness is home to the legendary monster, 'Nessie', of which there are usually several reported sightings a year. The loch is 23 miles (37km) long, about 1 mile (1.6km) wide and over 750ft (228m) deep. This massive body of water never freezes and the yearly surface temperature ranges between 39–63°F (4–17°C). Loch Ness is open to both the North Sea and the Atlantic via the Caledonian Canal. There is a salmon farm just south of Dores, which rears fry and smelts in freshwater cages. The most famous view of Loch Ness is on the opposite bank by the ruined Castle Urquhart. This is situated on the main road south from Inverness to Fort William and is rarely free of tourists.

PLANNING

LOCATION
Dores is situated on the eastern shore of Loch Ness, about 8 miles (12.9km) south-west of Inverness.

HOW TO GET THERE
From Inverness, which is also the nearest railway station, take the B862 south to Dores. There are only a couple of buses a day from Inverness to Dores: check timetables with Highland Scottish Omnibuses +44 (0) 1463 233371.

WHERE TO STAY
The Highlands of Scotland Tourist Board lists a wide range of accommodation in the area, www.visithighlands.com. Or contact the Scottish Tourist Board, details on page 190.

WHAT TO SHOOT
The rural landscape just outside Dores, with rolling fields and scattered trees can look good as the mist clears, or when covered in frost and the B862 south out of Dores soon gets you onto the moors and lochs for some snowy landscapes. Urquhart Castle, on the opposite shore, is one of Scotland's popular attractions.

WHAT TO TAKE
Wideangle, standard and telephoto lenses, filters, tripod and beanbag. Take plenty of warm clothing, eg. thermals, gloves, balaclava and thick socks, boots and waterproof trousers.

BEST TIMES OF YEAR
The beach at the Dores Inn is popular in summer. There are plenty of parking and picnic areas along the B852 which follows the shore where you can get some interesting shots.

ORDNANCE SURVEY MAP
Landranger sheet 26

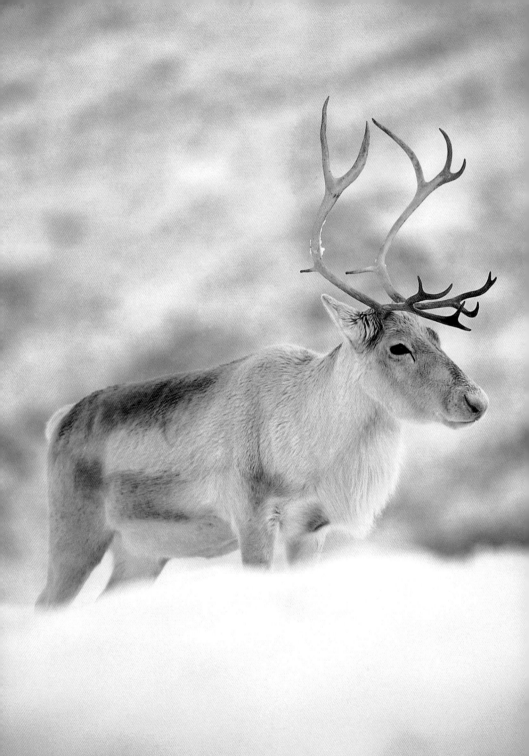

The Cairngorms

The Cairngorms National Park is the largest in Britain at 1,400 square miles (3,626sq.km) and covers roughly 10 per cent of Scotland. Many rare and protected species are found there, and one of the more unusual inhabitants are reindeer. The herd that occupies the northern slopes of the Cairngorms was founded in 1952 and is now run by The Reindeer Company in Glenmore. The reindeer live year round on the open hillside, over about 6,000 acres (2,428ha). Photographers are welcome, there is no additional fee, but prints or slides for The Reindeer Company's use are appreciated.

Towards the end of a tour one snowy December day, I lingered with a small group of animals, concentrating on one white female in particular. Even with tame animals, whose fear circle is much smaller than wild ones, I prefer to remain at a distance. A 300mm lens not only gave me a comfortable working distance but also rendered the hill behind soft.

Thanks to the snow, light levels were high, but metering a white subject in snow is tricky. As luck would have it, there was a midtoned reindeer in the same light from which I took a spot reading. Without this convenience, I would have decided which part of the animal I wanted to be midtone and based my exposure on that, checking that the palest parts of the reindeer in which I wanted detail to show were no more than two stops lighter than this.

Even if the Cairngorms do not provide the same experience of photographing reindeer as Svalbard or Alaska, close encounters at least are assured. And in midwinter, there is one vital ingredient that neither of these other locations can claim: daylight.

Expert Advice

While working conditions are not at their easiest in snow, reindeer look their best in winter. The thick coat comes in during September, moulting out in June. Although May and June is the best time to photograph calves, their fly-pestered mothers are not so photogenic then.

Left Towards the end of a tour I lingered with a small group, concentrating on one female in particular. *Technical details not recorded*

The Cairngorms

The Cairngorms is a range of wild and rugged granite peaks whose jagged tops reach 4,000ft (1,219m), including Cairn Gorm the sixth highest mountain in Scotland. Thick swathes of heather blossom a vivid shade of purple in late summer; however, it is winter that reveals the savage beauty of the Cairngorms – windswept snowdrifts and tumbling cascades that freeze to solid ice. It is a popular place for hill walking and skiing; go to www.cairngorms.co.uk for advice, weather updates and ranger contact details. Even in these severe conditions, wildlife abounds, with species such as ptarmigan, arctic hare, snow bunting and red grouse. Red deer will descend to the valley floor and mix with the resident population of reindeer, and red squirres forage for food at the forest edge.

Above Cladonia lichen with ice. This is what reindeer survive on during the winter months. The species' success is in no small part due to its ability to convert sparse vegetation into body mass.

Nikon FE2 with MF 90mm lens, exposure details not recorded, Kodachrome 64, tripod

PLANNING

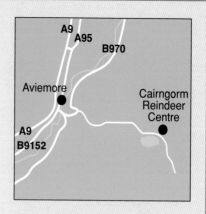

LOCATION
The Cairngorms National Park is located in the eastern Highlands, near Aviemore.

HOW TO GET THERE
Take the A9 north from Perth to Inverness then turn off at the junction for Aviemore.
The Reindeer Company visitors' centre and shop is in Glenmore on the way to the Cairngorm ski slopes, tel/fax: +44 (0) 1479 861228, www.reindeer-company.demon.co.uk. Tours take place every day except Christmas and New Year's day, from the visitors' centre.

WHERE TO STAY
The Tourist Information Centre in Aviemore, tel: +44 (0) 1478 810363 has full listings for local hotels and B&Bs. Alternatively, contact the Scottish Tourist Board, details on page 190.

WHAT TO SHOOT
Ancient Scots pine, mountain scenery and Loch Morlich. For wildlife, red squirrel, ptarmigan, red grouse, snow bunting and artcic hare.

There is plenty of opportunity to shoot reindeer portraits, but pictures of the animals running down the hillside and bulls sparring are more dynamic shots.

WHAT TO TAKE
If you are shooting in the snow for any length of time, dry, warm feet and a warm head go a long way to keeping the rest of you warm. A wind-stopping fleece hat is effective. Pad your tripod legs with pipe insulation for comfort.

BEST TIMES OF YEAR
Autumn, when the deer grass has changed colour and the sun is low or late summer for purple heather on the mountain tops.

ORDNANCE SURVEY MAP
Landranger sheet 36

Insh Marshes

LAPWINGS, REDSHANKS AND CURLEWS
FLOCK AGAINST THE DRAMATIC BACKDROP
OF RUTHVEN BARRACKS AT INSH MARSHES,
ONE OF THE MOST IMPORTANT WETLAND
AREAS IN EUROPE **PETE CAIRNS**

Insh Marshes is one of the largest natural floodplains in the UK. It has significant geological importance as well as providing a rich and diverse habitat for a large range of wildlife.

At the southern end of the marshes, Ruthven Barracks stands sentinel as a symbol of troubled times in the Highlands. Built in 1718, Ruthven provided a rallying point for Highlanders following the bloody battle of Culloden. It has been well preserved and is now owned by Historic Scotland and guarded by a small herd of highland cattle.

Most images I have seen of the barracks place the ruin in front of a cloudless summer sky – somehow not in keeping with its melancholy past. The promise of storm clouds as darkness fell prompted me to try to secure some images of the floodlit ruin against a brooding, twilight sky. I had taken such a shot previously, but failed to notice the potential of a conveniently situated flooded pool which, assuming still conditions, would offer a perfect reflection of the barracks. I started shooting as the sky grew darker, giving the barracks more prominence. I took a spot reading off one of the illuminated walls and, allowing for some bracketing, stuck with this throughout the shoot. At shutter speeds of between 5 and 30 seconds, camera stability was essential – the use of a sturdy tripod is a prerequisite for this type of work. As each image takes so long to set and expose, it was important for me to work as quickly as I could to secure as wide a range of pictures as possible as the light dimmed.

Above Ruthven Barracks, Strathspey. The building is illuminated each night as darkness falls and looks best against a brooding sky or fiery sunset (the shot is easily done looking south in winter). Use of the roadside pool provides the reflection, which gives balance to the overall composition. *Nikon F5 with 35–70mm lens, 15secs at f/16, Velvia 50, tripod*

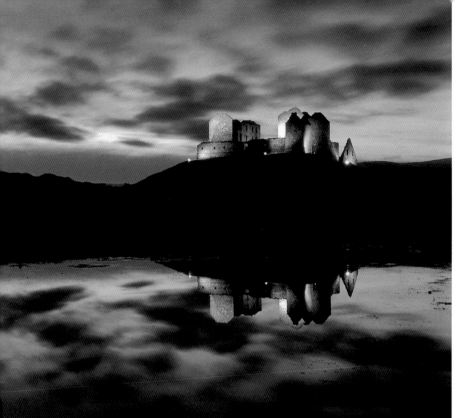

Insh Marshes

Insh Marshes is renowned internationally as a model of a natural floodplain managed exclusively for wildlife. It is a diverse and dynamic environment. Supporting more than 1,000 pairs of breeding waders in the summer, it is the most important mainland site for species that have declined elsewhere. Insh is internationally important for a large population of breeding waders, notably redshank, lapwing, snipe, curlew and oystercatcher. The marshes are also home to the highest number of breeding goldeneye in the UK. Roe deer and buzzards are ever present, with hen harriers and golden eagles often seen overhead.

Right Highland cow. Along with puffins, these are one of the most photographed animal subjects in Scotland. Like puffins, they are irresistible, but are best photographed from the roadside or with permission to enter the field, as they can be unpredictable.
Nikon F5 with 500mm lens, 1/125sec at f/5.6, Sensia 100, beanbag on ground

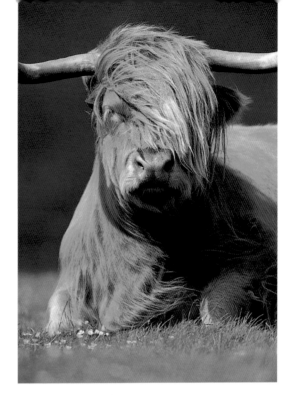

Left Melancholy thistle. Patches of 'weeds' often provide opportunity for dynamic images of wild flowers. A telephoto lens isolates a single flower, providing a more artistic interpretation.
Nikon F5 with 80–200mm lens, 1/30sec at f/4, Velvia 50, tripod

PLANNING

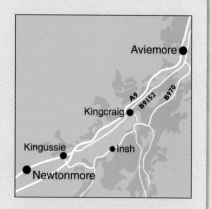

LOCATION
Between Kincraig and Kingussie, directly off the A9 main trunk from Perth to Inverness.

HOW TO GET THERE
By rail or coach to Kingussie. Great North Eastern Railway (GNER), www.gner.co.uk, operates a service from London to Inverness.

WHERE TO STAY
Several hotels, B&Bs, self-catering both in Kincraig and Kingussie. Try Suie Hotel +44 (0) 1540 651344 or visit www.kincraig.com.

WHAT TO SHOOT
Ruthven Barracks, landscapes across the marshes, fungi, flora, patterns, textures. Birds and mammals are not easy to approach close enough for photography but the site is particularly good for butterflies.

WHAT TO TAKE
A sturdy tripod is essential and a telephoto lens may be useful for taking close detail shots.

BEST TIMES OF DAY
Dawn and late evening, although on bright but overcast days, macro images can be secured throughout the day.

BEST TIMES OF YEAR
Winter is rewarding for frosted birches and ice patterns. Autumn is especially good, with swathes of golden bracken and vibrant birches and aspens.

ORDNANCE SURVEY MAP
Landranger sheet 35

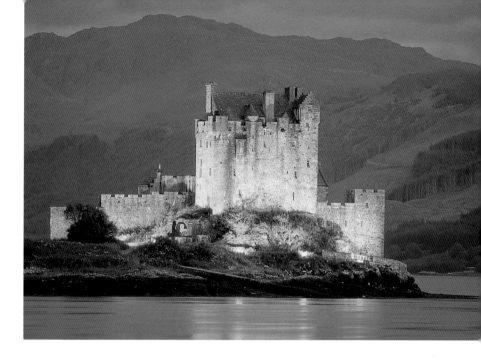

STANDING ON AN ISLET AT THE MEETING POINT OF THREE LOCHS, IT IS EASY TO SEE WHY EILEAN DONAN CASTLE IS ONE OF THE MOST PHOTOGRAPHED PLACES IN SCOTLAND **COLIN VARNDELL**

Although I had been to Scotland on previous photographic assignments I had not before spent time in the Western Highlands and I knew they offered abundant photographic opportunities. It was with this in mind that I took my family north to a rented cottage at Glenelg, near Glen Shiel. Our aim was to enjoy family fun and do all the 'touristy' activities during the day, leaving a little time for landscape photography in either the early mornings or evenings.

We visited the famous Eilean Donan Castle one afternoon and I was amazed to observe the hundreds of tourists as they jumped from their coaches and immediately started taking photographs. This must be the most photographed castle in Britain if not the world, and it appealed to me very much as a subject.

Above The fast-moving clouds may have blocked out the sunset, but I turned them to my advantage with this long exposure which mixed the twilight with floodlight. *Canon EOS 1N with 20–35mm lens, 20secs at f/11, Sensia 100, tripod*

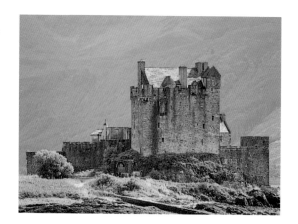

Right Usually I shoot a couple of pictures of a subject at the first moment of contact. I am anxious to get one 'in the bag', and this record of how I first perceive the subject will hopefully be vastly different from the final shot. This was my first encounter with the castle. *Camera with 70–200mm lens, 1/60sec at f/11, Velvia 50*

I did take a couple of straight record shots in pretty awful light that afternoon, and then spent some time driving around the loch to look at the building from various viewpoints.

In view of the fine, settled spell of weather at that time, and after some considerable persuasion, my family agreed to suffer a couple of sunsets at the castle. Actually it turned out to be me who suffered the ravages of highland midges at sunset while my wife and children went off to enjoy fish and chips. On neither evening was the castle floodlit on its most photogenic east side, and neither was the colour of the sky as spectacular as I had hoped.

FACTS ABOUT:

Eilean Donan Castle

The history of the castle dates from the 13th century when it was owned by the Mackenzie clan. It was destroyed by an English bombardment in 1719 during a Jacobite uprising. The castle today is a total restoration which was completed in 1932. The Castle, exhibitions and visitor centre are open every day between April and October, 10am–5.30pm.

After the second vigil, I decided to cross the bridge and shoot the building from a viewpoint which would include mountains in the background.

I prefer shooting with prime lenses as I have always felt they have an edge over zooms when it comes to critical sharpness. But here on the edge of the loch my movements were restricted and the only way to obtain the composition I wanted was to use a zoom lens, see picture on page 56. By this time the castle was floodlit on its west side, and there was still light in the sky. Although the sky was actually two stops darker than the floodlit castle I knew from experience that the floodlighting would require an additional stop which would in turn yield a slightly brighter sky and give detail on the distant mountains.

As in all extreme conditions when the opportunity allows, I bracketed in both half and full stops either side of my calculated exposure in order to ensure a good result. As it turned out, my original exposure value proved to be the correct one.

Below Late in the day, thick brooding clouds hung low over Loch Garry. Suddenly a shaft of sunlight stabbed into the loch and the water briefly sparkled against the mountains. I metered directly from the water. *Camera with 300mm lens, 1/125sec at f/11, Velvia 50*

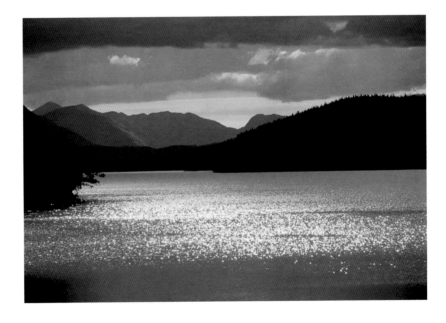

PLANNING

LOCATION
North-west highlands on A87 between Glen Shiel and Kyle of Lochalsh.

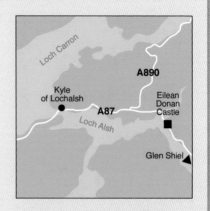

HOW TO GET THERE
From Fort William take the A82 north to Invergarry and join A87 westbound. From Inverness take the A82 southbound to Invermoriston and join A887 westbound which eventually joins the A87. Please note, there is limited public transport but it is infrequent, and will not necessarily stop at photogenic sites. It is therefore essential to have your own independent transport.

WHERE TO STAY
Tourism is the main industry for this area of Scotland and therefore B&Bs are abundant. Contact the local tourist centre at Kyle of Lochalsh for an accommodation list, tel: +44 (0) 1599 534276, or go to www.visithighlands.com

WHAT TO SHOOT
This area is so photogenic there seems to be a picture at every turn of the road. In addition to the wonderful landscape, the brochs at Glenelg are also of photographic interest. These circular stone structures are a type of small fortress unique to Scotland dating back to around 100BC.

WHAT TO TAKE
Be prepared for wet weather as this highland area attracts the highest level of rainfall in Britain. Waterproof clothing and footwear is essential, and take midge repellent and a hat for those tiny blood-sucking insects which will descend upon you in swarms during the summer months.

BEST TIMES OF YEAR
Eilean Donan Castle is photogenic all year but especially so in spring and autumn.

ORDNANCE SURVEY MAP
Landranger sheet 33

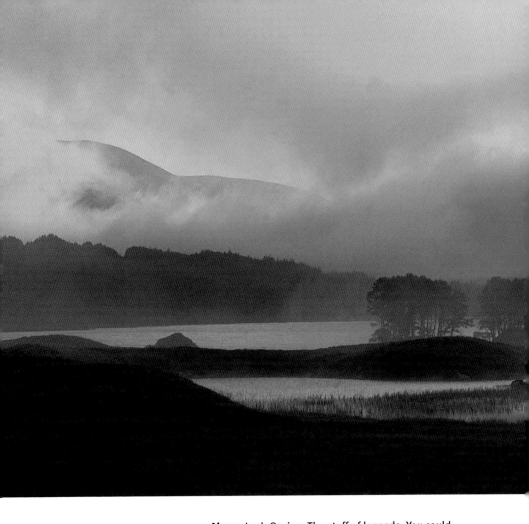

Above Loch Ossian. The stuff of legends. You could image the Gaelic poet himself appearing out of the dawn mists over Loch Ossian. As the sun rose, the swirling mist created constantly changing silhouettes and shapes, making every shot different; the frames either side of this one weren't worth keeping.
Nikon F90 with 70–200mm lens, exposure not recorded, Provia 100F, supported by van

Corrour

NOT FAR FROM SPECTACULAR FORT WILLIAM AND BEN NEVIS, CORROUR INHABITS A REMOTE AND WILD CORNER OF THE WEST HIGHLANDS **SUE SCOTT**

Amazingly, the easiest way to get to Corrour is by train, on the West Highland line, one of the most scenic railways in Britain. It's very strange seeing the little two-carriage train trundling across the moor, where you would expect only to see red deer and moorland birds. On arrival, I took a few shots of the hostel, which nestles in a cluster of Scots pines on the loch shore, and looks like something taken straight out of a Norwegian fairytale.

The next morning the loch was partly hidden by thick swirling mists. The scene was ethereal, and constantly changing by the second, so I grabbed a few shots with a 70–200mm zoom lens, isolating the best bits of mist-shrouded trees and islands. An hour later, the mist had lifted and there wasn't another cloud for the rest of the day.

I find the vegetation in such weather-stressed places fascinating for photography, and the colours are often strange too – peach-coloured bog asphodel

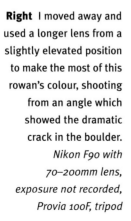

Right I moved away and used a longer lens from a slightly elevated position to make the most of this rowan's colour, shooting from an angle which showed the dramatic crack in the boulder.
Nikon F90 with 70–200mm lens, exposure not recorded, Provia 100F, tripod

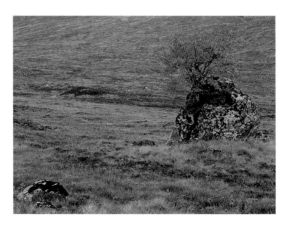

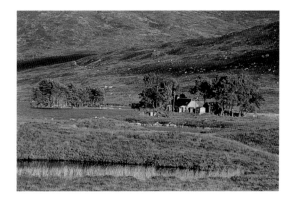

Right The hostel at Corrour is worthy of a few shots before you succumb to rest, warmth and refreshment after a long day's trek. It's best lit in the afternoon, with the loch as a backdrop.
Nikon F90 with 35–80mm lens, exposure not recorded, Provia 100F

leaves against pale grey lichens, for instance. Particular favourites are isolated boulders covered in mosses and lichens in a sea of orange grass, the white bell-shaped flowers and bright red berries of cowberry, and the brown seed heads of bog asphodel. Even the ubiquitous bracken was resplendent in autumn gold, and worth a few shots.

I resolved to go to Corrour station, hoping the weather would hold. Luckily it did, and the late afternoon light with a slightly overcast sky was perfect for accentuating the orange leaves against the dull moorland background.

Corrour

Corrour is owned by the Corrour Estate, and is surrounded by peat moorland and mountains more than 3,000ft (914m) high. Loch Ossian, about 4 miles (6.4km) long, fills the bottom of the glen, with about two-thirds of it surrounded by conifer plantations. There is no access for public vehicles, and it's an 11-mile (17.7km) walk in. But at the west end of the loch, Corrour station, on the West Highland line, is only 45 minutes from Fort William, and the highest station in Britain at 1,350ft (411.5m). It's an easy way to reach a really remote area.

PLANNING

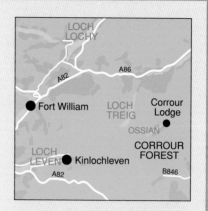

LOCATION
Corrour station is 15 miles (24km) east of Fort William.

HOW TO GET THERE
By the West Highland train line, www.firstscotrail.com. Or alternatively, walk 11 miles (17.7km) from Luiblea on the A86.

WHERE TO STAY
Corrour Station Bunkhouse, self-catering accommodation, Corrour Estate, tel: + 44 (0) 1397 732200, www.corrour.co.uk; Loch Ossian Youth Hostel, tel: 08700 041139, www.syha.org.uk. For other accommodation call Spean Bridge Tourist Information Centre, tel +44 (0) 1397 712576.

WHAT TO SHOOT
Loch and moorland scenery and plants, pine plantations, red deer.

WHAT TO TAKE
Everything, but you will have to carry it all, so a comfortable rucksack is most important. Tripod and polarizers, midge repellent in summer, good walking boots, waterproofs and layers. Be prepared for adverse weather, even in summer, and follow safety guidelines for walking.

BEST TIMES OF YEAR
September in the Highlands can be glorious – not too warm for walking and the moor grass has turned a beautiful shade of orange-brown. Late spring is often good and being snow-bound in winter might also be fun!

BEST TIME OF DAY
Morning mists and evening light are particularly good.

ORDNANCE SURVEY MAP
Landranger sheets 41 and 42

OFTEN OVERLOOKED, LOCH A'CHROISG WITH ITS FREEZING WHITE MISTS, ICE PATTERNS AND MIRROR-SHARP REFLECTIONS MAKES A BEAUTIFULLY BLEAK WINTER SCENE **IAN CAMERON**

Below Frost melting from bracken fronds and saplings in early morning sunshine at Achnasheen. *Pentax 67 with 55–100mm lens, 1/8sec at f/22, Velvia 50*

Loch a'Chroisg – it doesn't exactly roll off the tongue and I have to admit my pronunciation of it would leave native Scotsmen grimacing. It is the sort of location that people drive past, when the spectacular peaks of the Torridon mountains and the ancient pine forests bordering Loch Maree loom only a few miles further on. I find the raw beauty of Loch a'Chroisg utterly compelling and sometimes the urgency to continue my journey is forgotten.

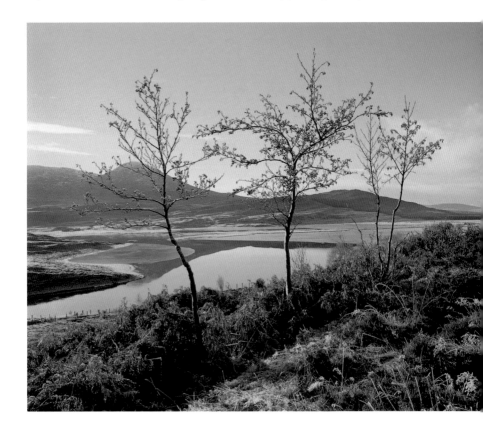

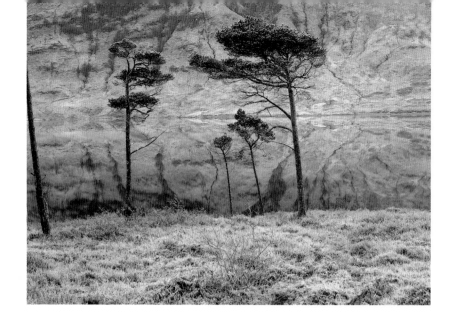

Above Bleak and beautiful, Loch a'Chroisg's charms have the power to seduce a dedicated photographer from his course.
Pentax 67 with 55–100mm zoom lens, 1sec at f/22, Velvia 50

Right These frosted plants and ice patterns are at the edge of the loch looking west towards Glen Torridon.
Pentax 67 with 45mm lens, 2secs at f/22, Velvia 50

Loch a'Chroisg

A naturally formed loch approximately one mile long and a few hundred yards across, Loch a'Chroisg is situated in an east–west direction and drains into Glen Torridon. The southern side of the loch rises out of the water to a height of 1,700ft (518.2m), and this provides natural shelter against wind and inclement weather. The northern shore gently slopes into the water and comprises mainly rocky boulders situated in small bays. It is accessed by means of a single-track road.

Loch a'Chroisg is a popular venue for trout and salmon fishing. Heron, osprey, divers and mergansers take advantage of the rich bounty. This is an excellent location to photograph red deer, particularly during the winter months when sightings are virtually guaranteed.

Expert Advice

The loch's orientation means the sun can rise and set along its entire length, and the steep hill on the southern shore provides a natural windbreak. In the right conditions, beautiful mirror-smooth reflections result. Loch a'Chroisg is a bleak location and as such it seems right to emphasize a sense of loneliness and desolation.

On a clear January morning I got up early and then headed west towards Kinlochewe. When I reached the loch I found myself utterly transfixed by the view before me. A perfect reflection on the loch, with freezing white mist rising from the valley floor and thick frost coating the grass, trees and bracken. Colour seemed to have been leached out of the landscape and the chilling sense of cold and the stillness of the air was almost tangible.

I set up my tripod at the side of the loch opposite a stand of scrawny Scots pine trees, their spindly appearance complementing the barren landscape. I had to raise the tripod to its maximum height in order to keep the tops of the trees within the bulk of the background hills. This eliminated any hint of white sky in the frame, which would certainly have diluted the overall impact.

Once you have started exploring this beautiful loch, photographic opportunities seem boundless and you will become transfixed. Do not neglect the split dead tree, or the ice patterns and rocky moraine at the edge of the water.

PLANNING

LOCATION

Loch a'Chroisg lies in an east–west orientation, accessed at its northern shore by a single-track road which has many pull-ins and passing places. The loch is protected on both sides by large hills. The plunging scree slopes on the southern shore provide shelter from the wind.

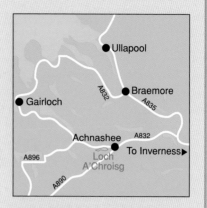

HOW TO GET THERE

Take the A832 Achnasheen turn-off towards Kinlochewe at its junction with the A890 and follow the single track road until you see the head of the loch, and the pine stand is clearly visible from the road.

WHERE TO STAY

Kinlochewe at the end of the single track road is the nearest place for food, drink and accommodation. For full listings contact the Scottish Tourist Board, details on page 190.

WHAT TO SHOOT

Ice patterns, reflections, the wonderful storm-damaged tree at the water's edge, sunrise and sunsets along the length of the loch, close-ups of groups of red deer that descend from the hills. Try to go on a windless day.

WHAT TO TAKE

Your usual camera gear, including telephotos for the deer, a flask of hot drink and something to eat, walking boots and a windproof jacket as it can get bitterly cold.

BEST TIMES OF YEAR

Winter suits this location best, but for strong colour try late autumn – the rich red bracken-covered slopes with a dusting of early snow at the summits is a very beautiful sight.

ORDNANCE SURVEY MAP

Landranger sheet 19

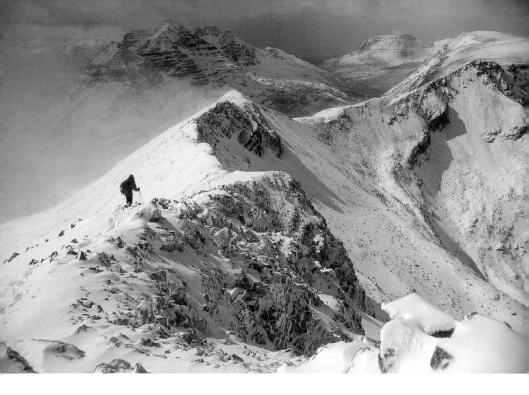

THE TORRIDON AREA INCLUDES A LOCH, GLEN AND VILLAGE OF
THE SAME NAME AND BOASTS SOME OF THE MOST MAGNIFICENT
MOUNTAIN PEAKS IN THE HIGHLANDS **HARRY HALL**

Although less publicized than Glen Coe, Cairn Gorm or Ben Nevis, the Torridon mountains contain some of the most challenging peaks in Scotland. 'Hardly anyone comes here,' was Queen Victoria's observation of the area, on one of her many visits and it pretty well summed up our campsite at Torridon, empty except for our small tent, pitched in the wintery conditions.

With late winter snow forecast, a friend and I threw the gear in the car and headed for the north-west. Short winter days require fast and efficient movement on the hills, so I keep my camera gear lightweight. Due to wet, cold conditions I took my Nikon FM2N, which will work without batteries in

Above Forcing the route through drifting snow along the ridge on Spidean Coire nan Clach, the Beinn Eighe Massif. *Nikon FM2N with 28–85mm lens, 1/250sec at f/5.6, Provia 100*

Torridon

very cold conditions, and has no complex circuitry to malfunction when wet. A 28–85mm lens and polarizing filter completed the kit.

This was put to the test on our first day, when I inadvertently undid the karabiner holding my camera bag, and, instead of releasing my rope, the camera bag fell to the ground then rolled to the foot of the gully some 1,300ft (about 400m) below. After a 45-minute downhill trudge, we found the camera pouch. Amazingly, when I opened it, nothing seemed to be broken. Reunited with my camera I was inspired to photograph the Horns of Alligin in the late afternoon light with Beinn Dearg as a backdrop.

My companion, Phil, had organized a day on Beinn Eighe, a mountain with many peaks and ridges in the neighbouring National Nature Reserve. An early start enabled us to reach the main summit ridge by mid-morning. With a northerly wind blowing around us, we trudged knee deep in fresh snow. Above us, a blue sky mottled with clouds promised a fine day for photography and with the peaks at the eastern end of the massif under our belts we headed westward.

FACTS ABOUT:

Torridon

Situated in the north-west of Scotland, the characteristic shape of the Torridon mountains is due to erosion of the ancient Torridonian red sandstone by glacial shift during the last ice age. In 1607 iron smelting in Scotland was begun on the shores of Loch Maree where canons were made for about 60 years. During the clearances, the area became infamous when tenant farmers were moved onto exhausted land already used by crofters, causing widespread misery. In 1951 a Lancaster Bomber crashed near the summit of Ben Eighe and, though the crew survived the crash, they perished in the cold weather. This led to the formation of the RAF Mountain Rescue team, which has since saved the lives of many servicemen and civilians.

From a small knoll on Spidean Coire nan Clach the ridge swung northward, revealing the summit of Liathach in the distance. A short distance ahead of me, Phil made an ideal focal point for a photograph, see page 68. Quickly getting the camera out, I shot eight frames as he fought his way along the ridge, the wind moving the clouds rapidly across the sky giving each shot a totally different background.

We continued along a narrow ridge towards an isolated peak. This was a good vantage point from which to photograph the cliffs of Sail Mhor towering above Loch Coire Mhic Fhearchair; in the distance the dappled shadows and sunlight played on Baosbheinn and Beinn Eoin. I supported my camera on a boulder, steadying it in the wind. I bracketed the exposures to account for the difference between highlights and shadows.

Below The Ramparts of Sail Mhor tower above Loch Coire Mhic Fhearchair with Baosbheinn and Beinn an Eoin in the distance. *Nikon FM2N with 28–85mm lens, 1/125sec at f/5.6, Provia 100*

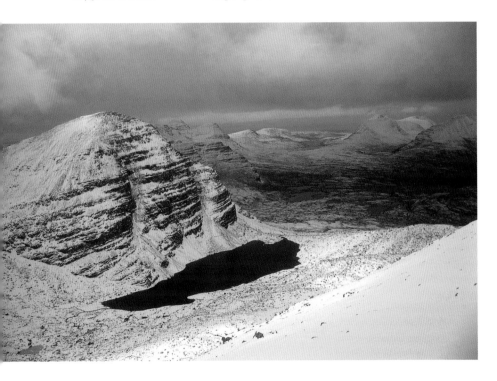

PLANNING

LOCATION
The Torridon mountains lie at the head of Loch Torridon in Wester Ross, on the north-west coast of Scotland.

HOW TO GET THERE
From Inverness follow the A835 to Garve, then the A832 through Achnasheen to Kinlochewe. Turn left and the A896 passes through Glen Torridon.

WHERE TO STAY
Contact the Scottish Tourist Board, details on page 190, for a selection of holiday cottages, B&Bs, hotels and hostels. Bars serve food at Sheildaig, Torridon and Kinlochewe.

WHAT TO SHOOT
Majestic mountains and lochside vistas in the valleys are ideal for landscape photography. Wildlife photographers may spot pine marten, golden eagles, ptarmigan, otters, highland cattle and red deer.

WHAT TO TAKE
Climbing equipment and mountaineering skills are essential. The glens need stout footwear, warm, waterproof clothing and midge repellent in the summer. Keep camera gear light.

BEST TIMES OF YEAR
The scenery is spectacular all year round. Winter snowscapes are magical, but take care to be prepared when hiking. Contact the local Scottish Natural Heritage (SNH) office for advice, tel: +44 (0) 1445 760254.

ORDNANCE SURVEY MAP
Landranger sheets 19, 24 and 25

PART TWO THE LOWLANDS & COAST

FROM FINDHORN TO CULLEN, THE MORAY FIRTH COAST IS A DELIGHTFUL STRETCH, DOTTED WITH CHARACTERFUL FISHING PORTS, CRAGGY COVES AND SANDY BEACHES **IAN CAMERON**

Moray Firth Coast

The Moray coastline covers all stops between Findhorn and Cullen and is wonderfully varied. Golden strips of sand at Findhorn, delightful sheltered sandy bays at Hopeman with colourful beach huts, the intoxicating coconut smell of acres of gorse and the undulating sand dunes of Lossiemouth. Further east are the picturesque fishing harbours at Burghead, Findochty and Buckie.

Bow Fiddle Rock, a wave-cut, natural arch can be seen from the clifftop path near Portknockie and

Left With a low viewpoint, I needed to squeeze out as much depth of field as possible so I focused a third of the distance into the picture and then selected a tiny aperture.

Pentax 67ll with 55–110mm lens, Velvia 50, polarizer, 81B warm-up filter, tripod

Cullen. It is a dramatic sight to enter the little village of Portknockie and look down over a yawning chasm and see sharp jagged rocks, swirling blue sea and a number of sea stacks glistening white from the guano of cormorants, shags and fulmars.

I have visited Bow Fiddle Rock during all seasons, at all times of day and think the best viewpoint is near the water's edge. This means a steep descent down the footpath to the valley floor. Bow Fiddle Rock faces north, if the sun is too low it doesn't reach the southern cliff tops, leaving the rock arch in shadow. The magical ingredients are a low tide, calm seas and little or no wind.

It's worth experimenting with viewpoints, and I was surprised to find that if I lowered my tripod towards the ground I could use the smooth surface of a rock pool to reflect the arch. The sun lighting the arch provides the centrepiece and the barnacle-encrusted rocks punctuate the mirror surface of the water, completing the composition.

The Moray Coastline

Magnificent Moray is a land of milk and honey – well, salmon and whisky at any rate. The broad meander of the River Spey empties into the Moray Firth, its crystal-clear waters exploited by the distilleries, fishermen and ospreys alike. It's no accident that the RAF has two air bases at Kinloss and Lossiemouth, for Moray is renowned as having more hours of sunshine than just about anywhere else in the UK.
A visit to the Wildlife Centre at Spey Bay will keep you informed about Moray Firth's resident population of dolphins, seals and minke whale. Take a boat trip from Buckie and it's possible you will see all three.

Below These weathered beach huts are at Hopeman Bay. Storm clouds were building, but suddenly the sun made a brief appearance below a layer of clouds, providing a theatrical lighting quality. I opted to shoot into the sun, metering from one of the sunlit huts to emphasize their texture.
Pentax 67II with 55–110mm lens, 1/4sec at f/22, Velvia 50, 81B warm-up filter, tripod

Left Low tide at Hopeman Bay sees the shoreline punctuated by weathered rocks. The foreground rock and the swirling sea are the essence of this picture.
Pentax 67II with 55–110mm lens, 4secs at f/22, 3-stop neutral-density graduated filter, tripod

PLANNING

LOCATION
The Moray coastline borders the southern side of the Moray Firth. It stretches between Findhorn and Cullen and includes Burghead, Hopeman, Lossiemouth, Spey Bay, Buckie, Findochty, and Portknockie.

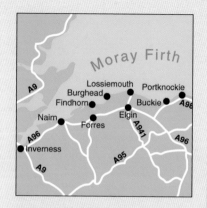

HOW TO GET THERE
Take the A96 east from Inverness to Forres, then follow the B9011 to Findhorn, then take the coastal roads laying north of the A96 to Burghead, Hopeman, and Lossiemouth, rejoining the A96 near Elgin then, the A98 coastal road from Fochabers to Cullen.

WHERE TO STAY
There is a wide selection of accommodation along the coast. For full listings contact the Scottish Tourist Board, details on page 190.

WHAT TO SHOOT
Idyllic sandy bays, windswept sand dunes, sunsets, hillsides covered in aromatic gorse, sea stacks, birds, seals, dolphins and minke whales, colourful fishing boats, nets, lobster pots and quaint seaside harbours.

WHAT TO TAKE
In addition to your usual camera take a wide-to-telephoto zoom and keep lens changes to a minimum. I would recommend bringing a tripod, polarizer and neutral-density graduated filters.

BEST TIMES OF YEAR
Good in all seasons, try winter for crashing seas and that most unusual sight, snow on the beaches and frosted sand dunes. On some occasions I have seen the northern lights flicker above the coast. Light pollution is very low here.

ORDNANCE SURVEY MAP
Landranger sheets 27 and 28

Left The nearby beach at Usan offers all sorts of close-up possibilities, including these blunt periwinkle shells. I shot these as soon as the sun had dropped below the horizon (to avoid harsh shadows), under a bright sky. An 81A warm-up filter compensated for the slight blue cast that can be expected in these lighting conditions. *Nikon F4 with, 90mm lens, 1/2sec at f/11, Velvia 50, 81A filter, tripod*

LYING BETWEEN ABERDEEN AND DUNDEE AND NEXT TO THE HARBOUR TOWN OF MONTROSE, MONTROSE BASIN IS AN IMPORTANT SITE FOR MIGRATORY BIRDS **NIALL BENVIE**

The Scottish Wildlife Trust's centre overlooking Montrose Basin is an ideal place from which to survey the 2,000-acre (809ha) tidal lagoon. The Basin is noted for its migratory geese, ducks and waders, but is also used by many other birds through the year.

In June, it is quite common to see up to 50 herons, both adults and youngsters, fishing on the Basin, or trying their luck in the muddy creeks which feed into it. This is not Florida, however, and an open approach simply drives the birds away.

I am often surprised by how readily some otherwise very shy birds accept a hide. Grey herons are a case in point. Indeed, I've been able to float in my amphibious hide very close to some individuals

without them figuring out a photographer was on board. It was this hide I chose when I decided to stake out a nearby pond used by a group of recently fledged youngsters. The hide has the advantage of providing a low perspective and the facility to support the camera and lens on a beanbag. On the downside, the user needs to wear chest waders and be prepared for a few hours of kneeling.

I learned that the young birds arrived there a little before first light and realized that I would need to be in position while it was still dark. A heavy dew had come in with the dawn so when, at around 5am, light began to kiss the edge of the pond, the fringing reeds sparkled and drooped. One of the herons had shown its tolerance of the hide by pecking at it but my attention was focused on another grey heron hunting at the other side of the pond, not far away. It was moving slowly, looking, pausing and probing in the shallows. It was then simply a matter of waiting for that moment of harmony between the light, the pose of the bird and the shapes of the reeds.

Below I took a spot reading from the heron's back and wings, wanting that to be the midtone value in the picture. It was then a matter of waiting for that moment of harmony between the light, pose of the bird and shapes of the reeds. *Nikon F4s with 300mm lens, 1/30sec at f/2.8, Sensia 100, beanbag*

Montrose

Montrose Basin is a local nature reserve and as such is governed by certain bylaws. If you want to use a hide, apply in the first instance to the Montrose Basin Visitor Centre, tel: +44 (0) 1674 676336 or e-mail: montrosebasin@swt.org.uk. The ranger can advise on those areas to avoid when birds are nesting. Although a permit is required to photograph herons at the nest, there are no legal restrictions at a pond or estuary. The mortality rate amongst first-year herons is about 70 per cent, the principal cause being starvation, so minimize disturbance, especially when young birds are still practising their fishing skills.

Left The car park at the Montrose Basin Wildlife Centre has been planted with various species of wild flower, including the dramatic viper's bugloss. The plant's height means that it is rarely found in this open location, but the wind is less likely to be a problem in the early morning or late evening. An overhead viewpoint with a very wideangle lens gave the impression of the flower spikes rocketing towards the camera.
Nikon F4s with 20mm lens, 1/8sec at f/5.6, Velvia 50, SB25 flashgun set to 1.7Ev, tripod

PLANNING

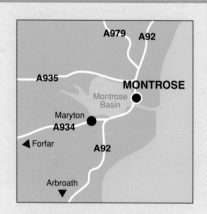

LOCATION
Montrose Basin is a tidal lagoon on Scotland's east coast, lying between Aberdeen and Dundee.

HOW TO GET THERE
For the wildlife centre, follow the A92 Montrose–Arbroath road out of town. Montrose is on the east coast mainline for rail travellers, the Basin and its surroundings are easily accessible by bike. For the Old Montrose pier, leave the A92 to join the A934 for Forfar and turn right at Maryton Kirk. After a short time, a track to the right, just after a bridge over the creek, leads to a small car park.

WHERE TO STAY
There is plenty of good accommodation in Montrose. Especially recommended are the Limes Guest House tel: +44 (0) 1674 677236, www.thelimesmontrose.co.uk and the Links Hotel tel: +44 (0) 1674 671000, www.bw-linkshotel.co.uk

WHAT TO SHOOT
The Basin is home to a large flock of mute swans, some of which are quite accessible. There is typical saltmarsh flora on the west side of the Basin and nearby, the big sandy beaches at Montrose, Lunan Bay and St Cyrus NNR provide good scenic opportunities.

WHAT TO TAKE
Even in summer a fleece jacket is normally called for early and late; it is often a little cooler in Montrose, compared with Brechin, just slightly inland.

BEST TIMES OF YEAR
Up to 40,000 pink-footed geese visit in October; eider ducks and wading birds can be photographed throughout the winter.

ORDNANCE SURVEY MAP
Landranger sheet 54

JUST OUTSIDE ARBROATH IN ANGUS, THE SEATON CLIFFS ARE
A STRIKING AND COLOURFUL SIGHT WITH THEIR DRAMATIC RED
SANDSTONE ROCK FORMATIONS **NIALL BENVIE**

M ention 'Red Rock Country' to any photographer
and there is a good chance that Arizona or the
Colorado plateau will be the first places to spring to
mind. However, Scotland has its own red rock
formations – albeit on a more modest scale – on the
coast north of Arbroath in Angus.

With its eastern aspect, the coastline here is best
photographed at first light. This provides the option
of warm light on the red sandstone cliffs or a striking
sunrise silhouette of the Deil's Heid. The reddest
light comes when the sun rises to meet a low cloud
base and is reflected back; the colours at these times
are as vivid as any from Arizona.

When I took the picture above, I had arrived at
Whiting Ness at 7am, giving myself about 40 minutes

Seaton Cliffs

Expert Advice

Most of the features on the Seaton Cliffs section are easily accessible from the trail, although getting to the seaward side of the Needle's E'e, where the view is better, involves a bit of climbing. This is not advisable in stormy weather or if there is a particularly high tide.

to find a composition and wait for sunrise. The sky was entirely cloudless so the sun was not going to be as red as I would have liked, so I set out to mitigate this by making a big block of the clear blue sky a key part of the composition. The sky is usually at its richest blue in the zenith – directly above us – so when I need to include it in frame, I shoot from as low an angle as possible. In this case, it meant going in close to the cliff with a 20mm lens. A bonus was the exaggeration of the dimensions of the low cliff, which now appeared to tower overhead.

Exposing directly lit sandstone can be a bit tricky, particularly when some areas are in full sun and others are semi-shaded. I decided it was most important that the conglomerate comprising the upper part of the cliff wasn't burned out, so I took a spot reading off a midtoned area – the plain sandstone at the far left of the picture – and underexposed by half a stop. I confirmed that this was a good midtone by metering the zenith, itself a reliable midtone if the sky is cloudless.

FACTS ABOUT: Seaton Cliffs

The most impressive features are found between Arbroath and Auchmithie. Here the rocks are mostly lower old red sandstone, although there is a rare section of upper old red sandstone, which has evaded erosion at Whiting Ness, the start of the Seaton Cliffs trail. The rock's relative softness makes it prone to sculpting by the sea and, in earlier epochs, the wind, too. This has resulted in a fine arch, the Needle's E'e, a substantial sea stack (now on dry land), the Deil's Heid, a series of fissure caves, and a gloup – or collapsed sea cave – known as the Gaylet Pot. Conglomerate or pudding stone features prominently in the geology and at Auchmithie the cliffs have yielded a pebble beach rich in quartz and jasper.

Above On the foreshore at Auchmithie pebbles worked free from the cliffs find their way into depressions in the sandstone. This reveals the fabulous patterns of lamination on the sandstone. The colours are best when an easterly wind is blowing a fine spray on the beach. *Nikon F4 with 90mm lens, 1/8sec at f/11, Velvia 50, 81A warm-up filter, tripod*

Below To avoid flare, I positioned myself so that the sun was hidden, but kept it as close to the edge of the rock as possible to imply it was just about to appear. Which, three minutes later, it did. Since I wanted the stack to be a solid silhouette, I went with a centre-weighted meter reading from the horizon just to the left of the rock. *Nikon F4 with 20mm lens, 1/60sec at f/11, Velvia 50, tripod*

PLANNING

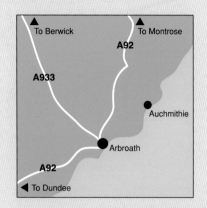

LOCATION
Arbroath is on the east coast, about 15 miles (25km) along the A92 from Dundee. The Seaton Cliffs trail begins at Whiting Ness, at the north end of Victoria Park. Auchmithie is another 3.7 miles (6km) up the coast.

HOW TO GET THERE
Arbroath is easily accessible by train. Alternatively, take the A92 from Montrose (approaching from the north) or from Dundee (approaching from the south). For Auchmithie, follow the A92 through Arbroath and turn right at the Meadowbank Inn on the northern outskirts. Take this minor road and follow the signs for Auchmithie.

WHERE TO STAY
Farmhouse Kitchen in Arbroath is well recommended, tel: +44 (0) 1241 860202. For further information contact the Scottish Tourist Board, details on page 190.

WHAT TO SHOOT
There are lots of interesting patterns within the sandstone, and the strand line at Auchmithie often has interesting objects. People fish for cod from the rocks below the Seaton Trail; I have photographed both the fish and the fishermen.

WHAT TO TAKE
The location is bitterly cold when the wind is out of the east, so dress accordingly. A pair of boots with good treads (but nothing metallic that will score the sandstone) is recommended if you want to climb round to the front of the Needle's E'e.

BEST TIMES OF YEAR
The summer months bring a profusion of flowers along the coast here, enjoying the locally lime-rich soils.

ORDNANCE SURVEY MAP
Landranger sheet 54

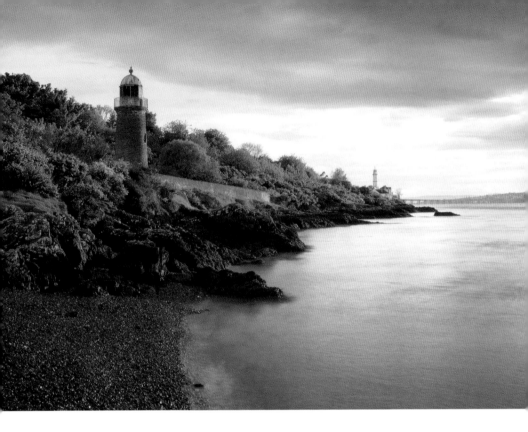

THIS PRETTY TOWN ON THE NORTH-EAST TIP OF FIFE OFFERS
PANORAMIC VIEWS OF THE TAY ESTUARY AND A PICTURESQUE
HARBOUR DOTTED WITH COLOURFUL BOATS **SIMON POWIS**

In addition to panoramic views of the Tay Estuary and a harbour full of small boats, there are two very photogenic lighthouses in Tayport and I'm often to be found perched on a rock, camera on tripod, patiently waiting for the light to change. It constantly amazes me how the locations I return to differ with the season and lighting conditions. No two visits ever seem the same when you have variation in both tides and light to contend with.

The main photograph shown here is of the West and East Lights, just a short walk upriver from the harbour. A small outcrop of rocks sticks out into the

Tayport

Left East and West Lights, Tayport. Late evening light provides the best conditions to capture the lighthouses. *Mamiya 7 with 80mm lens, 2secs at f/22, Velvia 50, 81A warm-up and 2-stop neutral-density graduated filter*

river at this point, providing a perfect location to capture the two lighthouses, with the sweep of the shoreline and a hint of the Tay road bridge and Dundee in the far distance. This particular image is one of many I have taken over recent years, trying to combine late evening light with a high tide and a sky that contains cloud, so as not to be too bland.

The boats in the harbour also provide plenty of scope for great images, from the confusion of the masts and rigging to the colourful reflections of the hulls in the still water. Use a telephoto and you can compress the boats in the foreground with the Sidlaw Hills, visible to the north of Dundee. Summer evenings also often spill glorious golden sunlight down in front of the hills. In contrast, the image of the harbour (overleaf) shows a rather brooding, menacing sky. Just after I had taken a few shots, a violent squall blew in that sent me scurrying for cover. I got a thorough drenching, but it was worth it.

Right East Light, Tayport. Clearer weather conditions and warm sunlight highlight the texture of the stonework on the lighthouse. *Mamiya 7, 80mm lens, 2secs at f/22, Velvia 50, 81A warm-up filter and polarizer*

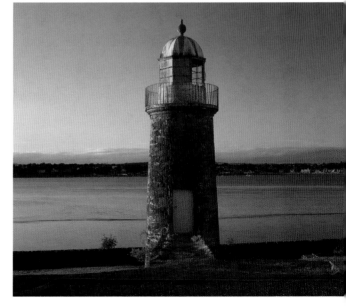

Tayport

Situated in the north-east corner of Fife, Tayport has been the site of a river crossing to Broughty Ferry and Dundee since the Middle Ages. With the arrival of the Tay rail bridge in the 19th century and the road bridge in the 1960s, the harbour became less well used and it's now occupied mostly by pleasure craft. A walk out of the southern end of Tayport leads you to Tentsmuir Forest, with its spectacular miles of sandy beaches and dunes.

Below Tayport Harbour. A threatening sky forewarned that a hasty retreat would be needed after taking this image. *Mamiya 7 with 80mm lens, 1/2sec at f/22 Velvia 50, 81A warm-up filter*

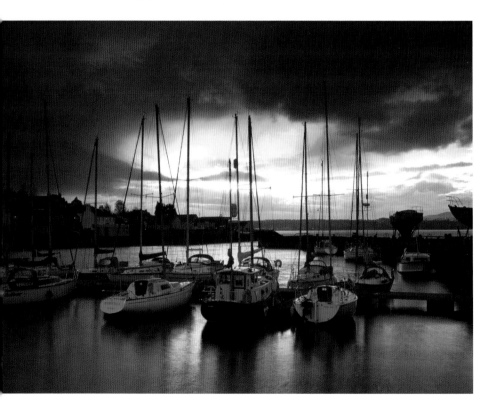

PLANNING

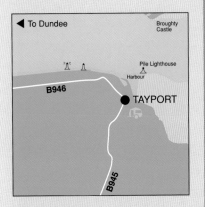

LOCATION
Tayport is located at the very north-east corner of Fife, approximately 5 miles (8km) from Dundee.

HOW TO GET THERE
From Dundee travel south over the road bridge, then take the B946 to Tayport. From the south take the A91 from Cupar or St Andrews, then follow the B945 into Tayport. Regular buses run from Dundee and St Andrews.

WHERE TO STAY
There is a wide range of accommodation available in Tayport, from B&Bs to campsites – with plenty more choice in nearby Dundee and St Andrews. For further information contact the Scottish Tourist Board, details on page 190.

WHAT TO SHOOT
Views of the Tay Estuary, boats in the harbour, the coastline and the lighthouses.

WHAT TO TAKE
Wideangle lens to take in all the boats, and short telephoto to isolate individual boats and their unique details.

BEST TIMES OF YEAR
Most boats are put in the water and activity increases around Easter onwards.

ORDNANCE SURVEY MAP
Landranger sheet 59

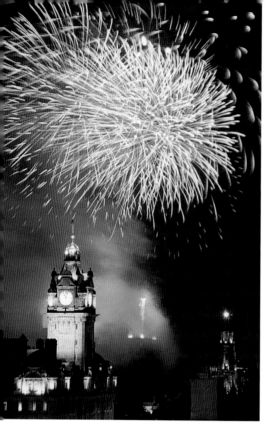

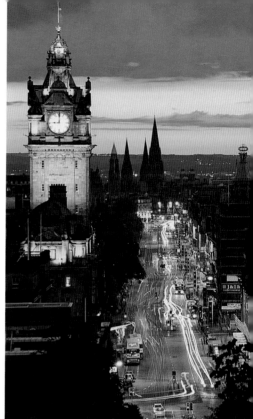

EDINBURGH, SCOTLAND'S CAPITAL AND WORLD HERITAGE CITY,
IS FULL OF ARCHITECTURAL, HISTORICAL AND CULTURAL INTEREST
AND WORTH A VISIT AT ANY TIME OF YEAR **DAVID DALZIEL**

Above Festival fireworks.
*Nikon F100 with
70–300mm lens,
exposure details not
recorded, Velvia 50,
tripod and cable release*

I would suggest a visit to Edinburgh in August, as this is when the famous International Festival takes place. Several different festivals combine to make up this huge, annual cultural event including the arts, film, literature and the blues and jazz festivals. The most famous event is the spectacular Military Tattoo, which takes place on the castle esplanade to packed audiences. Edinburgh's castle is perched high on Castle Rock in the city centre, with little to obscure the view while you stroll down Princes Street or walk along the beautiful Princes Street Gardens.

Edinburgh

90

Left Princes Street traffic trails.

Nikon F100 with 70–300mm lens, 20secs at f/32, Velvia 50, tripod and cable release

At the north end of Princes Street is Calton Hill, which provides a fantastic viewpoint over this picturesque city and the opportunity for some cityscapes overlooking Princes Street. Just after sunset is a good time, when it is possible to balance the city lights with the ambient light together with a long exposure to create traffic trails. It is also the best vantage point to witness one of the highlights of the festival, the fireworks display. On the final night of the festival thousands of spectators, gather here to witness this spectacular display set against the backdrop of Edinburgh Castle. As popular as Calton Hill is, it is still possible to find a spot with space to safely set up your tripod to take images of this colourful event. Set your camera to manual focus and use your bulb setting and cable/remote release. I focused my 70–300mm lens on the clock tower of the Balmoral Hotel and kept the shutter open for a few explosions, varying the exposure time with each frame. I also watched the first few explosions through my camera to ensure I was including the bursts of the

FACTS ABOUT:

Edinburgh

Edinburgh, the 'Athens of the North', is divided into the Medieval Old Town and the Georgian New Town. Scotland's capital is an important cultural and commercial city and is home to the Scottish Parliament. It is a popular tourist destination, with Edinburgh Castle being Scotland's most visited attraction. It has a population of 460,000 which doubles during the Festival. The Festival is Edinburgh's biggest annual attraction and lasts for three weeks in August but there is also a wealth of architecture and many museums with important artworks to entice the visitor.

fireworks in the frame. The display lasts for approximately 45 minutes, which is enough time to experiment with exposure times. The great advantage of using my cable release was that I was able to watch and enjoy the show while I was also taking photographs. Having previously framed my image and set my focus point there was no need for me to be stuck behind my viewfinder.

One more festival, and my personal favourite, is the Fringe Festival. Theatre companies and street performers descend on the Royal Mile to entertain the crowds of tourists who arrive from all corners of the globe. The Royal Mile is alive with the colour and the activity of jugglers, mime artists, human statues and musicians. There is so much opportunity for pictures that it is difficult to take your eye from the viewfinder. I concentrate on the colourful characters and their expressions and although it is difficult to keep the crowds from your candid shots, with a little patience it is possible.

A visit to Edinburgh during the Festival is a memorable experience and if you take your camera, you will take home some fantastic photographs.

Above Mimes.
Nikon F100 with 70–200mm lens, exposure details not recorded, Kodak EBX ISO 100

Below Double Act.
Nikon F100 with 24–85mm lens, exposure details not recorded, Kodak EBX ISO 100

PLANNING

LOCATION
East, central Scotland.

HOW TO GET THERE
Edinburgh is a major city with an international airport, excellent road and rail links to all major cities in the UK.

WHERE TO STAY
There are plenty of hotels and B&Bs to suit all pockets, but note, Edinburgh's population doubles in August during the Festival. Rooms may be scarce. For further information contact the Scottish Tourist Board, details on page 190, or go to www.edinburgh.org

WHAT TO SHOOT
Cityscapes, architecture on The Royal Mile, Festival street-performers and fireworks. For more information and advice about visiting the Edinburgh Festival go to www.eif.co.uk or www.edfringe.com

WHAT TO TAKE
Standard zoom and a mid-telephoto zoom lens. A tripod and cable release are essential for cityscapes and firework displays. A flashgun or on-camera flash for dull days.

BEST TIMES OF YEAR
Anytime, but the Festival in August is the main tourist attraction. There are big celebrations at New Year with a world-famous street party including live concerts and another fireworks display.

ORDNANCE SURVEY MAP
Landranger sheet 66

THIS 11TH-CENTURY CASTLE, SUPPOSEDLY HAUNTED BY A
MEDIEVAL THIEF, LIES ON THE FIRTH OF FORTH ESTUARY NOT FAR
FROM KIRKCALDY **PHILIP HAWKINS**

Below While the ruined castle sits on a hilltop there is another hilltop not far to the east. I set up the tripod on this site anticipating a good golden glow from the rising sun. I wasn't disappointed. The ruined keep was transformed during the golden hour. *Canon EOS 3 with 28–70mm lens, 1/8sec at f/16, Velvia 50*

When I first visited MacDuff's Castle it was a miserable, rainy day and photography was impossible. However, as soon as I saw the castle, I knew straight away that it would be beautifully illuminated by a winter sunrise. So, I returned another day, arriving well before sunrise to find the position that I had selected previously.

The castle was built in the 14th century on a small hill overlooking the Firth of Forth. I wanted to show the ruined keep, the main surviving feature of MacDuff's Castle, in its context. I therefore placed it in the centre of the frame with the winding trail threading up the hill on the left-hand side, leaving space on the right-hand side to show the steep drop of the hillside, and what would at one time have been the castle courtyard.

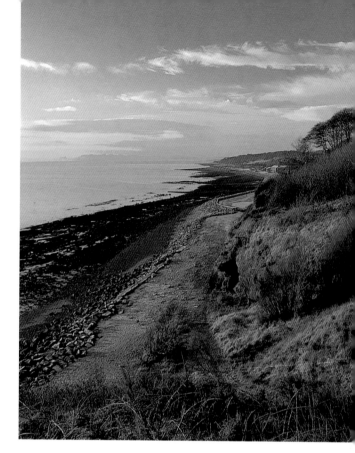

Right View west over the coastal path from MacDuff's Castle, taken from the same spot as the picture below left, but looking in the opposite direction across the Forth Estuary towards the Pentland Hills. This suited a vertical composition with the meandering path leading the eye. *Canon EOS 3 with 28–70mm lens, 1/8sec at f/16, Velvia 50*

The sun duly rose and as I had anticipated, it was perfect. Arising above the flat expanse of the Forth Estuary meant that MacDuff's Castle received the full benefit of the magnificent golden hour glowing a deep, rich, vibrant red.

After shooting the castle I swivelled the tripod head 180 degrees and took the vertical shot shown here, above. Working with a zoom lens allowed me to take a number of alternative compositions without having to move around, which was just as well as I had a steep drop right behind me!

When I'd finished on the hilltop I climbed down onto the coastal path that runs below MacDuff's Cave. I took further shots using the frost-covered rocks adjacent to the beach as foreground interest.

Expert Advice
The ruins of MacDuff's Castle are reputedly haunted by Mary Sibbald, a medieval thief, intent on scaring all visitors to the site. However, as we all know, ghosts are notoriously afraid of being caught on camera.

FACTS ABOUT:

MacDuff's Castle

MacDuff's Castle was originally built in the 11th century by the MacDuff Earls of Fife. This castle was razed by Edward I of England. The existing castle was built by the Wemyss family in the 14th century. As the years went by the castle was little used as the Wemyss family had several other, preferable fortresses at their disposal. It eventually fell into ruin and the upper parts were dismantled for safety reasons. Several castles along the Firth of Forth shoreline occupy dramatic, hilltop locations, but most of these are to be found on the southern coast. MacDuff's Castle is the best example on the northern coast of the estuary.

Below MacDuff's Cave, coastal path below MacDuff's Castle. Climbing down from the castle onto the coastal path, I found MacDuff's Cave lit by the same golden rays as the castle had been. The warm, red glow of the cave's exterior contrasted well with the deep, dark shadow of the interior. It's also a good place to hide if Mary Sibbald's ghost comes after you!
Canon EOS 3 with 28–70mm lens, 1/8sec at f/16, Velvia 50

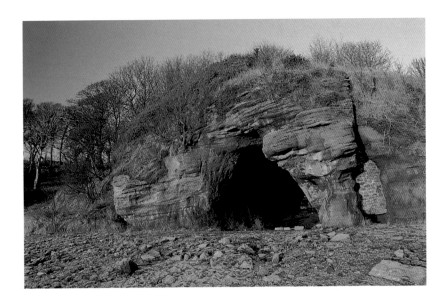

PLANNING

LOCATION
Buckhaven is found on the east coast of Fife approximately 6 miles (9.7km) from Kirkcaldy.

HOW TO GET THERE
If you're coming from the south, after crossing the Forth Road Bridge follow signs for 'East Fife Coastal Trail' on the A921. After Kirkcaldy take the A955 into Buckhaven. MacDuff's Castle is located on the outskirts of Buckhaven between the town and the village of East Wemyss. Park near the cemetery and follow the path that runs along the east side and around to the coast.

WHERE TO STAY
The Belvedere Hotel in West Wemyss is recommended, tel: +44 (0) 1592 654167. For full listings in the area contact the Scottish Tourist Board, details on page 190.

WHAT TO SHOOT
Apart from the castle itself, there are panoramic views to the west, east and south. Numerous coastal paths and walkways are to be found along the east coast from Buckhaven to St Andrews and the harbours of Anstruther and Crail are colourful and interesting.

WHAT TO TAKE
Wideangle lenses, polarizers and neutral-density graduated filters. Warm clothing.

BEST TIMES OF DAY
Early morning and evening are usually best, but all day is also excellent during the winter.

ORDNANCE SURVEY MAP
Landranger sheet 59

ST ANDREWS IS SCOTLAND'S OLDEST UNIVERSITY TOWN AND THE 'HOME OF GOLF' WITH WINDING MEDIEVAL STREETS AND A PRETTY HARBOUR **STAN FARROW**

St Andrews is a small town with nearly all its interesting parts in the centre. Here the grandeur of the ancient University of St Andrews, with 600 years of history, jostles side-by-side with the medieval street-plan and quaint fishermen's cottages of the older part of town.

I usually like to be opportunistic with my photography, but the scarlet gowns of St Andrews students are a colourful sight, and they are especially striking when contrasted with the rough sandstone blocks of the pier. Traditionally the students walk along the pier after chapel, and it was this spectacle that I set out to photograph one Sunday morning.

The students usually walk right to the end of the pier and then return along the top. I waited until there were students going in both directions with a few silhouetted against the sky. This is fairly simple

Above Students wearing their red gowns make a colourful sight as they walk along the pier on Sunday morning after chapel. The negative was later scanned and Photoshop was used to select and copy the red colour of the gowns. The image was turned into monochrome, and then converted back to RGB before the red colour was pasted back in.
Nikon F80 with 28–80mm lens, 1/125sec, Reala 100, UV filter, tripod

St Andrews

St Andrews

The town of St Andrews has been of prime importance to Scotland for over 1,000 years. St Andrews was the first cathedral city in Scotland and the country's first university town. Today, with just over 6,000 students, the university is very small in comparison to many others in the UK. The game of golf was invented in St Andrews in the 15th century and the Royal & Ancient Golf Club is still where the rules of golf are set. In the summer tourists arrive to join the golfers and students. With a medieval street plan, castle, cathedral, four miles of sandy beaches and a tiny harbour, St Andrews is a picturesque spot and any photographer's dream.

Below This image of the East Sands was taken one August evening. I was particularly attracted by the simplicity of the sand, sea and sky. The stick figures on the wet sand seemed to give a sense of vast scale.
Nikon F80 with 28–80mm lens, 1/125sec, Provia 100F, polarizing filter

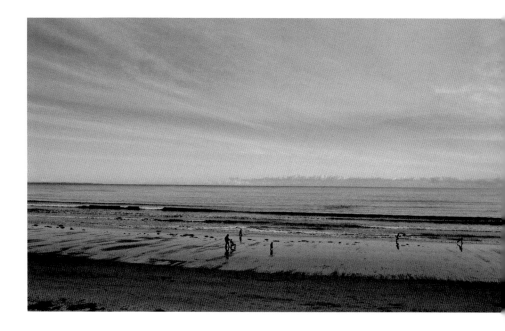

photography, and I didn't need a very high shutter speed or great depth of field.

The harbour wall is almost completely monochrome already, and I wanted to strengthen the image to make the red of the gowns stand out against a black & white background. I scanned the image and used Photoshop to create the effect I was looking for. I started by selecting and copying the red gowns. These would be pasted back in after I had finished working on the rest of the image. Next I converted the image to greyscale, created a copy of the background layer, and posterized it, softening the overall effect by reducing the opacity of the copy layer. Finally, I flattened the two layers and converted the greyscale image back into an RGB file. I was now ready to paste the red gowns back into the picture to create the black, white and red effect.

One part of the town often overlooked is the tiny harbour that nestles below the more imposing ruins of the cathedral. This was built at a time when St Andrews was a place of medieval pilgrimage. Today, the harbour is a quiet backwater, one of several similar harbours in the East Neuk of Fife that depend on dwindling inshore fisheries for survival. As the harbour offers a tranquil alternative to the town centre, it is often a place of refuge for me.

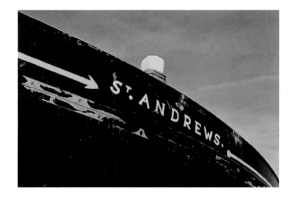

Left The contrast between the bulwark of this boat and the blue sky particularly appealed to me. The boat was the *Bonnie Lass*, but had the port of origin painted on the stern too, which seemed more apt. I handheld my camera and took care to get the curve of the boat running from corner to corner of the frame. I'd forgotten my polarizer, but I don't think a deeper blue sky would have improved this image.
Nikon F80 with 28–80mm lens, 1/180sec, Provia 100F, UV filter

PLANNING

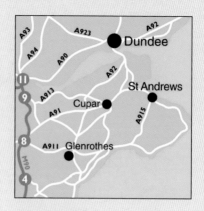

LOCATION
St Andrews is about 50 miles (80.5km) north of Edinburgh and 12 miles (19km) from Dundee.

HOW TO GET THERE
Drive north from Edinburgh across the Forth Bridge and follow the M90. Leave after Kinross at Junction 8 and follow the A91 to St Andrews.

WHERE TO STAY
There are plenty of places to stay, ranging from hostels to world-class hotels. In August and September it's best to book ahead. Contact the St Andrews Tourist Information Office tel: +44 (0) 1334 472021 or the Scottish Tourist Board, details on page 190.

WHAT TO SHOOT
Medieval buildings and houses, the older parts of the University are particularly attractive. The nearby beaches offer vistas of sand against a backdrop of sea and sky. The small picturesque fishing harbour offers a contrast to the formality of the University and the golf courses.

WHAT TO TAKE
Wideangle lenses with UV and polarizing filters are essential. Short telephotos or zooms are useful for capturing detail. Take a warm pullover or jacket because even in midsummer the sea breezes can be chilling.

BEST TIMES OF YEAR
St Andrews is pleasant at all times of the year, and daylight hours are long in the summer months. The light in eastern Scotland has a special clarity that is particularly good in early spring and late September. Winter is the best time for trying out many of the local coastal walks.

ORDNANCE SURVEY MAP
Landranger sheet 59

Bass Rock

Left To illustrate the sheer mass of birds at Bass Rock, I found a position where I could look down onto the colony. I zoomed back to 100mm and manually focused on the middle distance birds. I was able to retain good depth of field and arrest the movement of the birds in flight.
Canon EOS 3 with 70–200mm lens, 1/500sec at f/8, Sensia 100

SITUATED NOT FAR TO THE SOUTH-EAST OF EDINBURGH, IN THE FIRTH OF FORTH, BASS ROCK IS ONE OF BRITAIN'S MOST IMPORTANT SEABIRD BREEDING GROUNDS **MARK HAMBLIN**

The sights, sounds and smells of thousands of gannets, rising wave after wave from the cliffs of Bass Rock, must rate as one of the finest wildlife spectacles in the world. There are birds in every direction; calling, pair bonding, incubating eggs, feeding chicks, hovering and plunging for fish. Bass Rock and the nearby island of Craigleath host thousands of breeding seabirds during the summer.

It was a windy day, and we were only given two hours on the island which meant I had to work fast. The conditions were perfect for taking flight pictures. The strong wind meant the birds were hanging almost motionless in the air, often coming within touching distance.

Exposure can sometimes be problematic when photographing birds in flight and on this occasion it was compounded because of the bright white plumage of the birds. My technique here was to take a meter reading from the mid-blue portion of the sky and then set this exposure manually on the camera. As the lighting conditions did not change I was able to take pictures at this predetermined exposure reading and obtain consistently good results.

Below left In order to maintain sharp focus, I set the autofocus to predictive mode. This is a continuous focus mode that keeps the bird in sharp focus as long as it isn't moving too quickly towards the camera. The head and eye of the bird are the most important parts to have sharp. *Canon EOS 3 with 70–200mm lens, 1/1000sec at f/5.6, Sensia 100*

Bass Rock

Bass Rock is famed for the estimated 30,000 pairs of gannets that nest there each year. The gannets, whose scientific name of *Sula bassana* is derived from the rock's name, are present all over the island and are reached by walking along a small trail that leads through the colony. Birds at all stages of development can be seen during July. Other birds on the island include shags which nest near the landing stage. A few guillemots and puffins also congregate here and are equally approachable. Craigleath has at least ten species of breeding seabird, including puffins, razorbills, shags, cormorants, kittiwakes and fulmars.

Left During the crossing to the island, the boat approached a group of puffins. As we got closer they began to take off, running across the water. Using predictive autofocus, I panned with this bird shooting on the high-speed motordrive setting. This was the only successful frame from a sequence of 12 shots. *Technical details not recorded*

Above As most seabirds are very approachable at their breeding grounds, there are plenty of opportunities for taking a range of pictures using different focal length lenses. The soft overcast lighting emphasized the colour and detail of the bird's head. *Technical details not recorded*

PLANNING

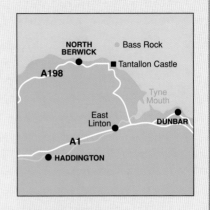

LOCATION
Bass Rock and Craigleath lie in the Firth of Forth, just off the coast from North Berwick, 20 miles (32km) east of Edinburgh.

HOW TO GET THERE
By car, take the A198 coast road off the A1. On reaching North Berwick head for the harbour. Boat trips are run from here and there is a notice board giving sailing times, tel: +44 (0) 1620 892838. Boat trips run daily from May to September, although landing depends on the weather.

WHERE TO STAY
The North Berwick Tourist Information website has a wide range of accommodation in the area, www.north-berwick.co.uk, or contact the Scottish Tourist Board, details on page 190.

WHAT TO SHOOT
On windy days shoot the birds in flight. Sunny weather is good for capturing them in action, while overcast lighting is ideal for close-up portraits.

WHAT TO TAKE
You'll need a telephoto zoom, a wideangle lens and plenty of film. Wear old clothing and take plenty to drink in hot weather.

BEST TIMES OF YEAR
Gannets are present from April to September. St Abbs head to the south is great for coastal scenery as well as flowers in spring.

ORDNANCE SURVEY MAP
Landranger sheet 67

AN EXCELLENT DAY TRIP FROM EDINBURGH TO ENJOY THE GENTLE SUMMITS, GLENS AND RESERVOIRS **KYRIAKOS KALORKOTI**

The Pentland Hills are just outside Edinburgh. The many climbs in the area are fairly easy and, on a clear day, they will reward you with superb views including Edinburgh and the Firth of Forth as well as the hills of Fife and Stirlingshire.

After an initial exploration I started the climb to Turnhouse Hill leading to Carnethy Hill (1,879ft or 573m). The walk can be extended considerably by exploring the many peaks that follow. I got to the top of a hillock near the start of the path and stopped immediately. The sun was low in the sky, and creating very striking shadows, adding extra interest to the magnificent colour and the structural qualities of the path leading up to the hills.

After setting up, I decided to use an 81B warm-up filter to bring out the colours of the grass and earth. This is a fairly mild filter so its use is rarely intrusive and benefits landscapes of this kind.

Having settled on an initial exposure value I usually then sweep the landscape, noting how far each important part departs from the chosen value, making sure that its rendered tone will be appropriate. This process leads to a final choice, which is often a compromise, since the various requirements can be conflicting and it is not always possible to use graduate filters to resolve the problem. After that I measure the various parts of the sky to decide what, if any, graduate filters to use. On this occasion I decided on a one-stop neutral-density graduated filter. It was important to leave the radiating clouds quite bright to provide an echo and continuation of the snow; a darker filter would have ruined the effect.

Right The low winter sun from the left provided attractive modelling for this view of the path sweeping up to Turnhouse and Carnethy Hills. *Ebony 45S with 80mm lens, 2secs at f/38, Velvia 50, 81B and 1-stop neutral-density graduated filters, tripod*

Expert Advice
I wanted not only to represent the beauty of this scene but also the feeling one has at the prospect of the climb ahead. One advantage of a large-format camera is the ability to alter perspective using movements. Here, back tilt emphasized the sweep of the path towards the summit and reduced the size of the hills but, not their impact. As Paul Klee noted in his diaries, the effect of an object does not depend on its size but the extent of the space on which it acts.

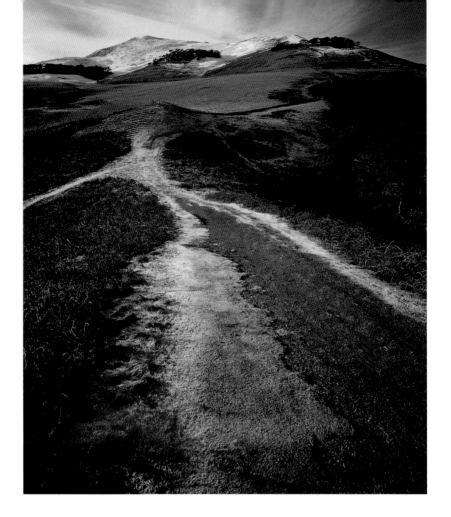

The Pentland Hills

The Pentland Hills were shaped by glaciers and lie 7 miles (11km) to the south-west of Edinburgh. They were designated as a Regional Park in 1984 and encompass pasture for sheep, grouse moor and some forest, as well as recreation facilities such as a dry ski slope. Some parts are used for army training and shooting ranges; these are clearly marked and are not significantly obtrusive. There are several manmade reservoirs, of which Glencorse is one of the oldest, supplying drinking water to Edinburgh and the surrounding area.

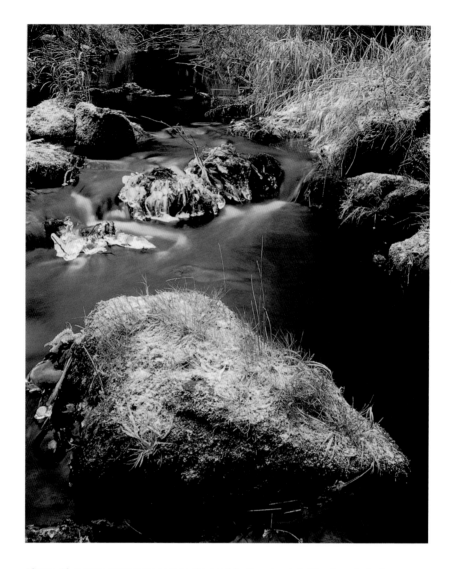

Above Glencorse Burn runs next to the road by the car park. The day started with freezing temperatures which ensured superb ice formations and frost. These, with the warm colours of the reeds and the flowing water were worth the freezing feet resulting from a lengthy set-up time.

Ebony 45S with 150mm lens, 4secs at f/32, Velvia 50, 81B filter, tripod

PLANNING

LOCATION
Flotterstone, Pentland Hills, near Edinburgh.

HOW TO GET THERE
By car, take the A702 from Edinburgh and continue after the sign for the dry ski slope at the outskirts; Flotterstone is signposted on your right. The public car park is just past the Flotterstone Inn on the right. From the south-west: along the A702 Flotterstone is about 4½ miles (7km) to your left after Carlops. Follow the signs to Scald Law for the position of the main photograph.

WHERE TO STAY
For full listings of accommodation in the area contact the Scottish Tourist Board, details on page 190.

WHAT TO SHOOT
Views reaching to the Firth of Forth, water studies, icicles, frosted leaves and fungi.

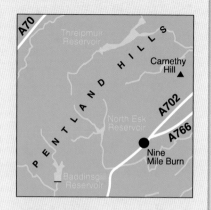

WHAT TO TAKE
Wideangle to standard lenses. Warm-up and graduated filters are essential. Wear warm clothing; the wind-chill factor is significant. Good boots are essential.

BEST TIMES OF YEAR
In early autumn the russet colours appear.

BEST TIMES OF DAY
Dawn to mid-afternoon for the main picture. Sunset shots from the top of the hills.

ORDNANCE SURVEY MAP
Landranger sheets 65 and 66

GLASGOW'S ARCHITECTURAL DIVERSITY WILL CATER FOR ALL TASTES AND INSPIRE STYLISH PHOTOGRAPHY **JOHN CARROLL**

Glasgow is a beautiful city of lush green parks, renovated sandstone buildings and modern architectural innovation. Although I often find myself driving north to some of Scotland's better-known areas, it is telling that some of my best photographs have been taken right on my own doorstep, in the centre of Glasgow.

One of my favourite locations is the regenerated area around the River Clyde. One evening, I headed to the river in anticipation of a good sunset. Having photographed the tower and science centre there many times before, I knew the titanium-clad surfaces would glow with the warm red and orange colouring of the sunset. I got into position in front of the small moat at the side of the centre. The sun was setting almost directly behind the tower enabling me to shoot a series of silhouettes. As the sun dipped below the horizon the titanium surface glowed as if on fire, with the sky in similar shades. I later headed up the river to capture a shot of one of the newly lit bridges, the cold blue light under the arches contrasting with the warmth of the street lights above.

Another favourite location of mine is Glasgow Cathedral and its Necropolis, as the grounds are a haven for urban wildlife. At the same time as taking some shots of the cathedral, I saw some roe deer feeding amongst the old gravestones and decided to return with a longer lens. I managed the trip a few weeks later, arriving early one morning. A couple of young roe deer eventually appeared and one started feeding on some overhanging leaves while the other settled down in the grass. I managed to capture a few shots of them before they quickly moved on.

Expert Advice

The banks of the River Clyde near Glasgow's city centre are home to the Scottish Exhibition and Conference Centre (SECC), nicknamed the 'Armadillo' by Glaswegians, and the Glasgow Science Centre and Millennium Tower on the opposite bank. This area has become a magnet for local photographers and tourists alike, attracted by the contemporary architectural design which is highly reflective by day and floodlit at night.

Right Glasgow Science Centre and Millennium Tower. Some of the first titanium clad constructions in Europe, these buildings have totally transformed the River Clyde in Glasgow. *Canon EOS 10D with 17–40mm lens, 5secs at f/16, ISO 100, tripod and cable release, polarizing filter*

Left Due to Glasgow City Council's lighting strategy many of the bridges along the river are now floodlit in a variety of colours. *Canon EOS 10D with 17–40mm lens, 30secs at f/16, ISO 100, tripod and cable release*

Above Normally timid, these roe deer have become used to the noise of people and traffic around the cathedral.

Canon EOS 1D MKII with 100–400mm lens, 1/320sec at f/5.6, ISO 400, beanbag

FACTS ABOUT:

Glasgow

Glasgow, or 'Glaschu' meaning 'a green hollow or place', is the largest city in Scotland. Standing on the banks of the River Clyde, Glasgow built its early wealth on the tobacco trade with America. From this wealth it became the second city of the British Empire in the 1800s and the shipbuilding capital of the world.

Recent years have seen Glasgow become European City of Culture in 1990 and UK City of Architecture and Design in 1999. Glasgow today is a bustling cosmopolitan city. It has a diverse range of architecture, from the art nouveau of Charles Rennie Mackintosh to the titanium, steel and glass of its modern, contemporary buildings.

PLANNING

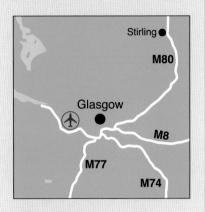

LOCATION
The city of Glasgow is in west-central Scotland on the banks of the River Clyde.

HOW TO GET THERE
Glasgow is well serviced by motorways, railways and international airports.

WHERE TO STAY
Glasgow has plenty of accommodation to cater for all budgets and tastes. Try the Holiday Inn Express Hotel in the heart of Glasgow's theatreland, close to the city centre, tel: 0870 400 9093, www.hiexpress.com.
For further information go to www.seeglasgow.com or contact the Scottish Tourist Board, details on page 190.

WHAT TO SHOOT
The architecture, in particular the SECC, Science Centre, Millennium Tower and Cathedral. Also the riverside, green parks and the many floodlit buildings and bridges in and around the city.

WHAT TO TAKE
Wideangle to standard lenses are most useful. A sturdy tripod and cable release are essential for photographing the floodlit buildings and bridges.

BEST TIMES OF YEAR
Glasgow is well worth a visit at any time of year.

BEST TIMES OF DAY
Any time, but particularly the evening when the lights come on, the setting sun casts a warm glow over the varied architecture or changes the colour of the titanium structures on the riverside.

ORDNANCE SURVEY MAP
Landranger sheet 64

The Lowther Hills

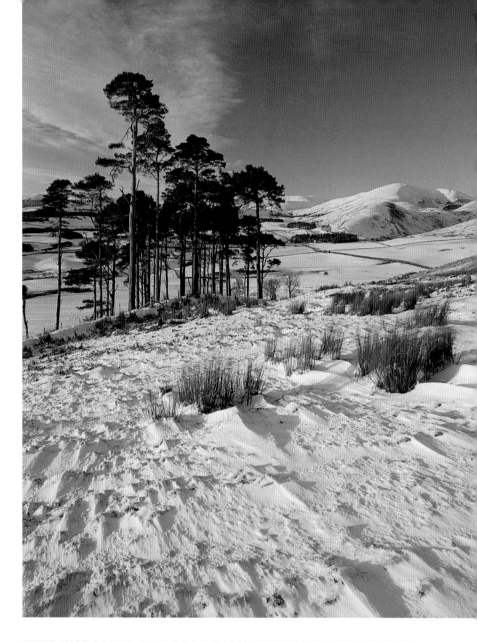

LYING JUST SOUTH OF GLASGOW, THE GENTLY ROLLING LOWTHER HILLS DISGUISE A VIOLENT HISTORY THAT FEATURES WILLIAM WALLACE AND BONNIE PRINCE CHARLIE **ALLAN DEVLIN**

Left I was looking for some foreground interest and saw these tufts of grass with the spindrift building up in their lee, creating interesting textures and shapes in the snow.
Bronica ETRSi with 50mm lens, 1/4sec at f/22, Velvia 50, polarizer and 81B warm-up filter

Expert Advice

Patience in this type of photography is a must. It's a beautiful day and you want to take photos, but arrive at your spot too early and by the time that perfect pre-sunset light evolves, you'll be too cold to release the shutter! So try to hang back and time it perfectly. Needless to say I slipped my leash and had to run around, jump up and down, and generally behave like a man possessed to keep myself warm. Hopefully nobody saw me.

The Lowther Hills, named after Lothus, King of the Picts, are a range of rolling hills that gently climb out of rugged moorland in southern Scotland. Part of the Southern Uplands, they are usually tame but, come winter, when the weather changes rapidly, you might find yourself in a winter wonderland one minute, and a ferocious, unforgiving wilderness the next.

These hills are also rich in history. William Wallace waged war here, Bonnie Prince Charlie marched his army northwards to eventual defeat at Culloden, and Covenanters hid and were killed in these hills fleeing religious persecution during the 'Killing Times'. All of which adds to their magic.

Three passes, each with a distinctive character, cross the Lowthers, running east–west from the upper Clyde valley to Nithsdale. They are Crawick, Mennock and, most spectacular of all, the Dalveen Pass. At the bottom of the Dalveen, off the main road, the small village of Durisdeer nestles in between the snow-clad hills. Almost forgotten in time, this sleepy hollow and the general area have a lot to offer the keen photographer and walker.

I noticed that there was a group of Scots pines just to the west of Durisdeer which would act as a strong feature for a photograph and spotted the interesting shapes in the snow to create some foreground interest. The shot was taken before the sun began to really sink. I would have liked a lower camera angle to get in close and accentuate the textures with a wideangle lens, but the lower I got the less I could see of the background.

I mounted the camera on a tripod, then used the depth of field scale on the lens to maximize the focus. Usually I trust the camera's built-in lightmeter and overexpose by two stops for the snow, but on this occasion I took an incident meter reading and bracketed half a stop either side. This was a stunningly beautiful and successful day on the hills.

The Lowther Hills

The Lowther Hills are typical of the Scottish lowlands, with their cleuchs (small gorges) and linns (waterfalls) hidden in between the rolling whalebacks that make up this range of hills. These hills are mainly made up of ordinary greywacke (heated up sandstone) but at its northern end, gold can be found. Wanlockhead, once known as 'God's treasure house in Scotland' was a mining village, mainly for lead, but gold has also been mined here through the ages. The gold found here is among the purest (22.8 carats) in the world and was used to make the Scottish Regalia.

Below Once again looking for potential foreground interest I moved further up the hill and used the grass. By this time the sun was just about set, as you can see by the redness of the light across the land.
Bronica ETRSi with 50mm lens, 1sec at f/22, Velvia 50, polarizer

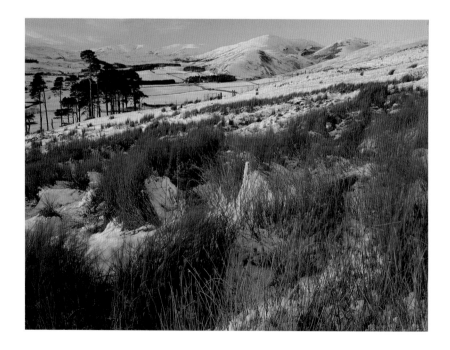

PLANNING

LOCATION
The Lowther Hills are situated 10 miles (16km) north of Dumfries and 40 miles (64km) south of Glasgow.

HOW TO GET THERE
The M74 runs just east of the hills. From it you can take the spectacular Dalveen Pass down to Durisdeer Mill where you turn off for Durisdeer village.

WHERE TO STAY
Thornhill has a range of B&Bs and hotels. For more information contact the Dumfries and Galloway Tourist Board, tel: +44 1387 253862, www.dumfriesandgalloway.co.uk.

WHAT TO SHOOT
Dalveen Pass and the scenic village of Durisdeer with snow-topped hills as a backdrop. Not far away Morton Castle sits in a promontory reflected in Morton Loch. Wildlife; grouse, wild goats, hares, various raptors, especially buzzards, and herons on the loch.

WHAT TO TAKE
Plenty of warm clothing, walking boots, map, something to eat and a warm drink (no shop in village). Lots of film, wideangle lenses mainly (telephotos handy for the unexpected), tripod and lightmeter.

BEST TIMES OF YEAR
Autumn, when the bracken begins to change colour and multitudes of browns, yellows and reds appear from the dying leaves. Or at the end of summer when the heather flowers carpet the hills in a purple haze of colour and the harvest is being collected in the valley floor.

ORDNANCE SURVEY MAP
Landranger sheet 78

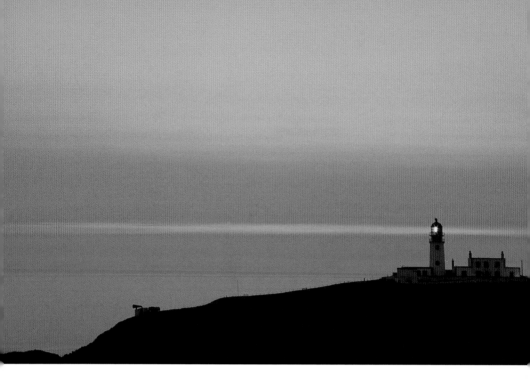

THE SOUTH-WESTERLY TIP OF GALLOWAY HAS A DISTINCTIVE ATMOSPHERE WITH ITS SHEER CLIFFS, SANDY BEACHES, WHITE-WASHED VILLAGES AND UNIQUE CLIMATE **ALLAN DEVLIN**

Killantringan Beach

The Rhins of Galloway is a very special part of Scotland, possessing a certain magic all of its own. Holding onto mainland Scotland by a thin thread of land, the Rhins (Gaelic for 'point' or 'promontory') is almost an island, with its own distinctive character. This quiet landscape rolls out in front of you until it meets the sea where it often drops off sheer. On the hilltops, overlooking a patchwork of fields, proudly sits the occasional farmhouse, isolated against the sky. At the sea's edge small scenic villages of little white-washed cottages sit as if challenging the sea to do its worst. Along the west coast the cliffs sometimes give way to beautiful sandy beaches which offer the photographer huge potential.

One of my favourite beaches is Killantringan which I try to visit at least once a year. It is about two miles north of Portpatrick, named after St Patrick, who is supposed to have crossed from Ireland in one single step, leaving his footprint on the rocks.

Black guillemots can be seen nesting in the harbour walls, fulmars and herring gulls are usually on the cliffs, while out at sea gannets dive bomb shoals of fish. The variety of coastal flora is quite stunning; sea campion, thrift and stonecrop all make a colourful display. Be sure to bring a macro lens and a diffuser to get rid of any harsh shadows.

For the main shot (left) I decided to use the lighthouse as foreground interest. It had been a hazy summer day and I knew that as the sun dropped into the horizon it would be diffused enough to shoot into it. Also, there might be the possibility of an interesting afterglow. As the sun set, I got a few shots of it dropping into the sea. I then had to wait another 20 minutes when a band of light started to form just level with the light on the lighthouse. It looked just like it was being projected across the sky.

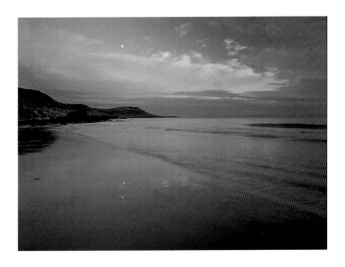

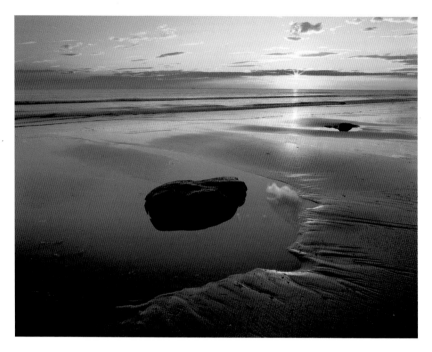

Above Killantringan Beach looking out to the coast of Antrim. When it gets near to the sun setting I am always on the lookout for something in the foreground to give depth or a lead in to the sunset, maybe even to balance it off against the sunset so it makes it a more comfortable picture to view.

Pentax 67 with 55mm lens, 20secs at f/22, 81B filter, polarizer, 2-stop neutral-density graduated filter

FACTS ABOUT: The Rhins of Galloway

While the rest of us get our usual wet summers, the Rhins seems to get more than its fair share of sunshine. This might be partly to do with the Gulf Stream, which flows up the west coast and keeps the worst of our weather at bay. It also means that within about 15 miles (24km) of Portpatrick there are at least four very different gardens to go and see. The most exotic of these, Logan Botanic Gardens, has a stunning display of palm trees and subtropical tree ferns in the summer. It's hard to believe you are actually in Scotland when you see it.

PLANNING

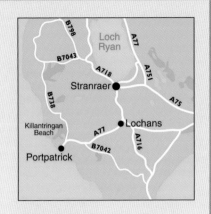

LOCATION
Killantringan lighthouse is 2 miles (3.2km) north of Portpatrick, which is 6 miles (9.6km) from Stranraer in the Rhins of Galloway.

HOW TO GET THERE
Coach or train to Stranraer then coach or car south on the A77 to Portpatrick. Parking: Portpatrick or at Killantringan lighthouse if you don't want to walk.

WHERE TO STAY
Portpatrick offers plenty of choice. For more information contact the Stanraer Tourist Office, tel: +44 (0) 1776 702595, or go to www.dumfriesandgalloway.co.uk

WHAT TO SHOOT
Killantringan lighthouse, or rock pools on the beach with a spectacular sunset as a backdrop. Also coastal flora/fauna and seabirds in among the cliffs. If you're lucky you might even see sea otters coming out onto the beach to eat their tea near sunset.

WHAT TO TAKE
Tripod, macro lens, diffuser, warm-up filters, polarizer and graduated neutral-density filters, spirit level, plenty of film, spare warm clothing and something nice to eat.

BEST TIMES OF DAY
Afternoon/sunset.

BEST TIMES OF YEAR
All year round, but autumn and spring also bring migrating birds.

ORDNANCE SURVEY MAP
Landranger sheet 82

THE BORDERS ARE OFTEN OVERLOOKED AS PHOTOGRAPHERS HEAD FOR THE HIGHLANDS BUT THIS AREA IS WELL WORTH EXPLORING **KEITH ROBESON**

Situated close to the River Tweed, the Eildon Hills lie at the centre of the Scottish Borders, surrounded by a rolling landscape of rounded hills. They are one of the best-known features of the Scottish Borders passed over by many travellers heading north for Edinburgh, or the Highlands. Scott's View, so named because it was Sir Walter Scott's favourite viewpoint, is probably the most captured scene in the Borders, and one that I have often photographed.

As a countryside ranger with Scottish Borders Council, the Eildon Hills are very familiar to me as I often lead guided walks over them. I am also involved in maintaining some of the paths, yet I never tire of visiting these hills. I wanted to take an image that would typify the Borders countryside, so the Eildon Hills were an obvious choice. However, I wanted to photograph something a little different to the usual pictures of these hills.

Above Monksford House and Eildon village are the main focus of this composition.
Minolta X-700 with 70–210mm lens, exposure details not recorded, polarizer, beanbag

Right November can be a time when mist will lie for much of the day in this part of the Tweed Valley. On this occasion the mist was constantly rising and falling, providing a changing scene as groups of trees emerged from the mist and disappeared again.
Minolta X-700 with 70–210mm lens, 1/250sec at f/8, Sensia 100

Right This recently restored sandstone statue of William Wallace stands in a woodland clearing above Dryburgh Abbey. It was in Selkirk, a few miles west of here, that Wallace was elected Governor of Scotland. *Minolta X-700 with 28–70mm lens, 1/125sec at f/8, Sensia 100, polarizer*

Expert Advice

Although I do not always take a tripod wherever I go, I do carry a beanbag. On this occasion I managed to locate a suitable, sturdy fence post and placed the beanbag on it to support my Minolta X-700 with 70–210mm zoom.

I headed for Wallace's Statue near Dryburgh one sunny morning while the autumn colours were still at their best. Initially, I was looking for a viewpoint that would include the statue, woodlands and the hills, but it was not working out as I had hoped, so I headed along to the edge of the wood where I was presented with the view shown in the main picture on page 122.

I rotated the polarizing filter to highlight the clouds without turning the sky too blue. With the lens set at its shortest focal length I was able to get the Tweed in the foreground and the hills filling the skyline. Then I just had to wait for the clouds to add a bit of interest to the sky before taking the shot.

I then turned the camera vertically and zoomed in to around 200mm to crop the scene so that Monksford House and Eildon village became the main focus of the composition, with the Tweed framing the bottom of the picture, with only the middle hill as a backdrop.

FACTS ABOUT:

Eildon Hills

The Eildon Hills comprise of three prominent peaks of hard igneous rock, which were originally formed when intrusions of molten magma cooled beneath a thick layer of sandstone. As a result of glaciation much of the softer sandstones have been worn away, leaving the hills standing proud. Since the Bronze Age, people have built their settlements on these hills. Today on Eildon Hill North, the remains of a huge Iron Age fort can be seen, particularly the defensive ramparts that surround the site, and at its height this settlement may have been inhabited by up to 2,000 people. These heather-covered hills are home to red grouse and other upland wildlife, and provide an excellent vantage point to view much of the Scottish Borders.

PLANNING

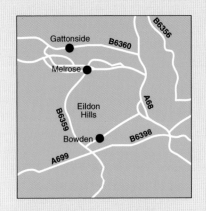

LOCATION
The Eildon Hills lie immediately south of Melrose in the heart of the Scottish Borders.

HOW TO GET THERE
For Melrose leave the A68 2 miles (3.2km) north of St Boswells and head west on the A6091. From Melrose the hills can be accessed on foot by following the signs for St Cuthbert's Way and the Eildon Walk. Scott's View and Wallace's Statue are signposted from the A68 at St Boswells.

WHERE TO STAY
There is a good range of accommodation in the Melrose area, for more information visit the Scottish Borders Tourist Board website www.scot-borders.co.uk

WHAT TO SHOOT
The Eildons from Scott's View is highly recommended, but also seek out other good views of the hills. Melrose and Dryburgh abbeys – Dryburgh also has some fine specimen trees, especially Cedar of Lebanon. Bemersyde Moss Nature Reserve – during the breeding season, this is the largest black-headed gull colony in Scotland; you can also see tufted ducks, pochards, ruddy ducks and otters. In winter the reserve provides a roost for greylag geese and whooper swans. The River Tweed, especially between Newtown St Boswells and Maxton (part of St Cuthbert's Way).

WHAT TO TAKE
If venturing onto the hills waterproof clothing and walking boots are recommended.

BEST TIMES OF YEAR
Late autumn for vibrant tree colour, mist effects and sunsets, winter time especially after a light covering of snow, August for heather flowering on the hills.

ORDNANCE SURVEY MAP
Landranger sheet 73

SMAILHOLM, NEAR KELSO, IS A PARTICULARLY WELL-PRESERVED EXAMPLE OF A 'BORDER PELE TOWER', BUILT TO PROTECT EARLY LANDOWNERS FROM LAWLESSNESS **KEITH ROBESON**

The remains of many Pele Towers still survive in the Scottish Borders – Smailholm Tower is one of the finest remaining examples. These tower houses were inhabited during the 14th to 17th centuries. Many were built after James V decreed that each man with a hundred pounds' worth of land was to build a barmkin (a walled-off area for outbuildings) for the safety of the people and livestock. During this period there were constant family feuds and cross-border raids on horseback between the Scots and the

Below You can almost imagine the marauding bands emerging through the mists of the 15th century. *Minolta XD7 with 35–70mm lens, exposure details not recorded, Fujichrome 100, polarizer*

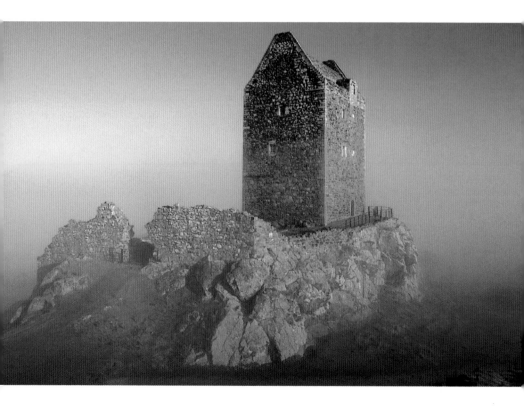

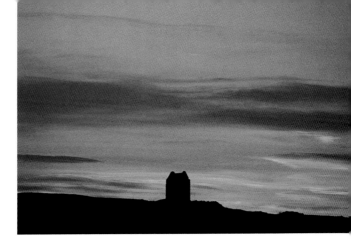

Right Silhouettes can be taken from the main road during the summer as the sun sets. Minolta X700 with 70–210mm lens, 1/30sec at f/8, Sensia 100, beanbag, skylight 1B filter

English. This was the time of the Border Reivers, whose way of life involved stealing cattle and any other possessions they could return home with. As a result of this lawlessness, many landowners built themselves castles or towers in which they could seek refuge whenever marauding parties threatened. Despite their solid construction, many of the Border Pele Towers are now in a ruinous state, but Smailholm has been well preserved and restored.

FACTS ABOUT:

Smailholm Tower

Smailholm Tower is constructed mainly from basalt rock quarried from the crags on which it stands, with dressed old red sandstone lintels and cornerstones incorporated. The tower is five storey's high linked by a spiral staircase. The two lower floors were used for storage and the upper three were the living quarters for the laird and his family. Around the tower is a barmkin, a walled-off area which would have contained outbuildings. It was built in the 15th century by the Pringle family but by 1645 it was owned by the Scott family, ancestors of Sir Walter Scott. By the 18th century the family had built and moved to the farmhouse at Sandyknowe. As a young boy Walter stayed with his grandparents at the nearby farm. Today the tower is owned by Historic Scotland.

Smailholm Tower sits in a prominent position on a rocky outcrop on the north side of the Tweed Valley with panoramic views in all directions. To the north lie the heather-covered Lammermuir Hills, to the west, the three peaks of the Eildon Hills and, looking southwards, the broad valley of the Tweed.

On the morning that the main photograph (page 126) was taken, the nearby town of Kelso was immersed in mist, bringing with it the promise of some dramatic photographs. I hoped that by travelling up onto higher ground I would be able to capture features in the landscape isolated by a sea of mist. When I arrived a thick blanket remained on the eastern side. The resulting effect was stunning, with mist lapping up close to the tower, engulfing it one minute and the next revealing the warm colours of the pink and grey stone lit by the autumn sun.

Below Another popular viewpoint of the tower looking across the 350-year-old mill pond which once powered a grainmill where the farm steading now sits. *Minolta XD7 with 70–210mm lens, 1/125sec at f/11, Fujichrome 100, polarizer, tripod*

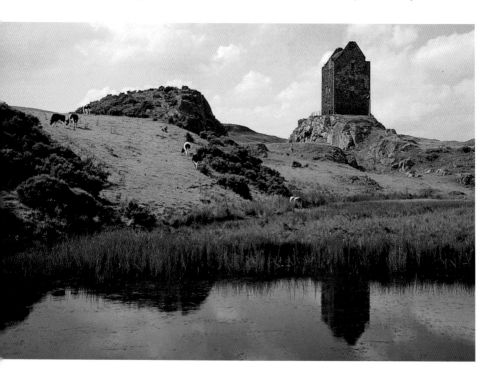

PLANNING

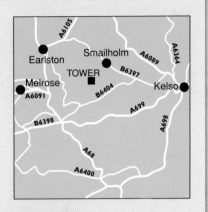

LOCATION
Smailholm Tower lies 4 miles (6.4km) north-east of St Boswells and 5 miles (8km) west of Kelso in the Scottish Borders.

HOW TO GET THERE
Leave the A68 at St Boswells and head east on the B6404 for 5 miles (8km), turn left onto a single-track road, continue through Sandyknowe farm steading and park in the car park close to the tower.

WHERE TO STAY
There is a good range of accommodation in the St Boswells and Kelso areas – for more information visit the Scottish Borders Tourist Board website at www.scot-borders.co.uk

WHAT TO SHOOT
The rocky crags provide a number of vantage points from which to photograph the tower and vistas across the Tweed Valley to the Cheviot Hills.

WHAT TO TAKE
Usual photographic equipment with tripod and polarizer.

BEST TIMES OF YEAR
Spring and early summer is good for wild flowers on the rocky crags.

ORDNANCE SURVEY MAP
Landranger sheet 74

PART THREE THE ISLANDS

LYING HALFWAY BETWEEN ORKNEY AND SHETLAND IN THE WILD AND REMOTE NORTHERN ISLES, FAIR ISLE IS MOST FAMOUS FOR ITS KNITWEAR, SHIPWRECKS AND SEABIRDS **PAUL GREEN**

An interest in bird photography and remote locations took me to the Shetland Islands for an autumn holiday that included a week on Fair Isle. I stayed at the Fair Isle Lodge and Bird Observatory which was established in 1948 to study bird migration and monitor the extensive populations of seabirds that breed on the island. I had joined a birdwatching holiday with the intention of photographing autumn migrants, and whilst bird photography did form an extremely enjoyable part of my trip, it was the island itself that really captured my imagination.

The higher, wilder and more exposed northern half of the island is covered in moorland and provides rough grazing for sheep, while the island's crofts with their outbuildings and low stone walls mark out the landscape in the southern half. The island is so small that you are never far from the rocky coast where

Expert Advice
Using long lenses from a distance flattens the perspective, reducing the apparent distance between elements in the composition. In this case the distant cliffs were brought into the top of the picture, providing a dark backdrop to the brightly lit foreground.

Left This whinchat was perched on a cabbage leaf on some cultivated land close to a croft. The bird was sufficiently confiding to allow me to approach close enough for this picture.
Canon EOS 3 with 500mm lens, 1/30sec at f/4, Sensia 100, tripod

deep gorges cut into the cliffs leading to small and often inaccessible beaches.

One morning I walked along the clifftops on the east coast. It was breezy and fresh with bright hazy sunshine. The sun was low enough to highlight texture and detail. I needed to exclude the sky which was bland and uninteresting in comparison with the deep blue of the sea. Standing on the top of the cliffs, I searched for a suitable composition. A vertical format worked best, emphasizing the deeply scored rock face angled diagonally into the sea, white spray from the swell adding the final element.

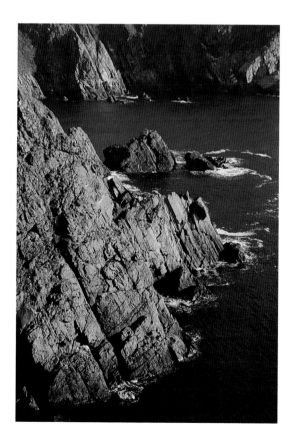

Left The contrast between the predominantly yellow rocks and dark blue sea caught my eye. From the cliffs opposite I used my zoom lens to compose the picture.
Canon EOS 3 with 100–400mm lens, 1/15sec at f/16, Sensia 100, tripod

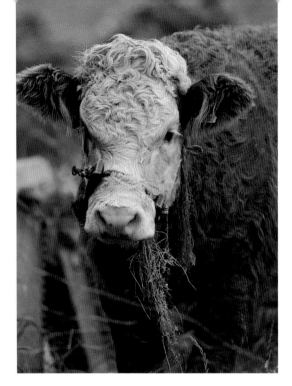

Left Having grown up on a farm I always find livestock interesting. Tethered on one of the crofts this Hereford bullock was enjoying a mouthful of hay as I took his picture.

Canon EOS 3, with 100–400mm lens, 1/60 sec at f/5.6, Sensia 100, tripod

Fair Isle

Fair Isle is one of Britain's most isolated inhabited islands. On the east coast, Sheep Rock provides an impressive landmark with cliffs rising to 328ft (100m), but this is nothing in comparison with the deeply indented western coast which is slashed by deep gorges or geos. Cliffs of 656ft (200m) can be found on the north-west coast. The island's population of about 70 inhabit crofts in a range of sizes, located in the southern end of the island where lower land and glacial deposits provide more fertile soil. Further north the island is covered by rough grazing and rocky moorland. The island is owned by the National Trust for Scotland and is famous for its knitwear and bird observatory. The entire coast and moorland are a Special Protection Area (SPA) with the cliffs providing breeding sites for nine seabird species of national importance and two of international importance.

PLANNING

LOCATION
Midway between mainland
Shetland and the Orkneys.

HOW TO GET THERE
By air from Tingwall airport near
Lerwick on mainland Shetland,
tel: +44 (0) 1595 840246.
By sea from Grutness Pier (near
Sumburgh) for a crossing that
takes about 2½ hours,
tel: +44 (0) 1595 760222.
Our trip was arranged by Shetland
Wildlife, tel: +44 (0) 1950 422483
www.shetlandwildlife.co.uk

WHERE TO STAY
Fair Isle Bird Observatory and
Lodge, tel: +44 (0) 1595 760258,
www.fairislebirdobs.co.uk. Some
additional accommodation is
provided by the islanders but must
be booked in advance.
Try Upper Leogh Guest House
tel: +44 (0) 1595 760248 or
Koolin Holiday Cottage
tel: +44 (0) 1595 760225.

WHAT TO SHOOT
Seabirds, seals, dolphins, whales,
cliffs, flora and fauna.

WHAT TO TAKE
Long lenses for the birds, with a
standard zoom for landscapes.
A telephoto zoom is useful for
picking out details in the landscape
as well as local farm animals and
the more approachable bird life.

BEST TIMES OF YEAR
The observatory and lodge are
open from April to October. Spring
migrants during the second half of
May. Autumn migrants during late
September and early October. June
and July for large colonies of
breeding seabirds. Plants such as
thrift, spring squill and bird's foot
trefoil are plentiful in June, adding
colour to the cliffs.

ORDNANCE SURVEY MAP
Landranger sheet 4

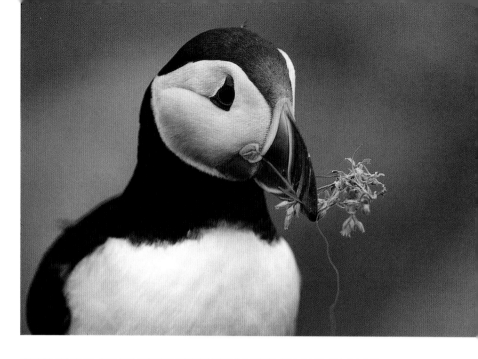

UNST IS THE MOST NORTHERLY INHABITED ISLAND IN BRITAIN AND, DESPITE ITS SIZE, HAS A HUGE DIVERSITY OF LANDSCAPES AND WILDLIFE, FROM PUFFINS TO PEAT BOGS **DAVID TOLLIDAY**

The first decision when planning a trip to Shetland involves the travel arrangements, as a car is essential. For me, the journey is an important part of any adventure and especially so when travelling to the most northerly part of Britain. My journey to Unst therefore involved a six-hour drive from Cheshire to Aberdeen, a 14-hour ferry crossing to Lerwick, then a drive across mainland Shetland, a ferry to Yell and then another ferry to Unst.

A visit to the Hermaness National Nature Reserve, on the north-western tip of Unst, was a must. The reserve was established in 1955 to protect the great skuas, known locally as the bonxie. On arriving at the 557 foot (170m) high cliffs, imagine my delight when right in front of me a puffin appeared, taking a small flower to its mate in the nest burrow.

Above As part of a pair, bonding puffins bring small flowers and other items to the nesting burrow. This one was at the top of Hermaness Cliffs. *Canon EOS 100 with 400mm lens, exposure details not recorded, Kodachrome 200*

Unst

Unst is the most northerly inhabited island in Britain, with a population of approximately 900. It has deserted sandy beaches, high cliffs, sheltered bays, peat bogs, heather-clad hills and freshwater lochs. The island supports a wide variety of wildlife, including spectacular seabird colonies, rare wild flowers and mammals such as otters, seals and killer whales. Shetland ponies can be seen by the roadside and there are pure-bred Shetland sheep.
There are two national nature reserves; at Hermaness for breeding birds and at the Keen of Hamar for wild flowers.

Below Otters are usually shy creatures, but this one allowed a very close approach. I eventually ran out of film, but who cares – the experience was magical.
Canon EOS 100 with 400mm lens, aperture priority at f/8, Sensia 100, tripod

One day, I saw an otter running along the beach. With my camera on a tripod I tried to get as close as I could. Possibly because of my very slow approach and my outline being partly concealed by the tripod, the otter didn't seem at all concerned about my presence. Gradually I got close enough for the otter to fill the frame with a 400mm lens. The otter and I then spent about an hour in each other's company. At one stage he went fishing and, on returning to the shore, came so close to me that I couldn't focus the camera. As he sat eating his meal I could hear the bones of the fish cracking. This has to be my best ever wildlife experience.

I was lucky to be offered a boat trip to Balta Island, which lies just offshore. On this island is a breeding colony of arctic terns. On sailing back we saw a large fin coming straight towards us. It belonged to one of three killer whales that eventually swam under our small boat, resurfaced the other side and then disappeared out to sea. This was more than enough excitement for any wildlife photographer.

Below The adult terns were busy feeding their youngsters. Anybody who has tried flight photography knows that you need a large bin for the discarded pictures. *Canon EOS 100 with 400mm lens, aperture priority at f/5.6, Sensia 100*

PLANNING

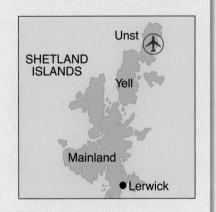

LOCATION
Unst is the most northerly of the Shetland Islands.

HOW TO GET THERE
A 14-hour ferry crossing from Aberdeen to Lerwick (NorthLink Ferries, tel: 0845 6000449, www.northlinkferries.co.uk) or a flight from various UK airports to Sumburgh on the mainland. Then two short ferry crossings between the mainland, Yell and Unst.

WHERE TO STAY
Clingera Guest House, Baltasound, tel: +44 (0) 1957 711579, is close to where the otter picture was taken. For more information contact Shetland Island Tourism, tel: +44 (0) 1595 693434, www.visitshetland.com

WHAT TO SHOOT
Seabirds including puffins, gannets and terns, wading birds, landscapes, wild flowers and, with luck, otters.

WHAT TO TAKE
Plenty of warm, waterproof clothing and sturdy footwear. A wideangle lens for landscapes, a macro lens for wild flowers and a telephoto lens of 300mm upwards for the birds.

BEST TIMES OF YEAR
May to July to photograph the seabird colonies and the breeding birds. In June it remains light until after midnight.

ORDNANCE SURVEY MAP
Landranger sheet 1

St Kilda

THIS GROUP OF ISLANDS, WEST OF THE OUTER HEBRIDES, ARE A WORLD HERITAGE SITE AND HAVE A FASCINATING HISTORY OF THE SURVIVAL AND EVACUATION OF ITS INHABITANTS **SUE SCOTT**

Apart from learning to dive, the most difficult part of this shot (below) was getting to St Kilda, as it's way out in the Atlantic, and very exposed. But in spite of the logistics, it's become a top British location for underwater photographers. Even if you don't dive, St Kilda is worth the effort. It really is spectacular and nothing prepares you for the sheer grandeur of its cliffs, the highest in Britain at over 1,410ft (430m), and tall rock stacks, white with thousands of seabirds.

St Kilda

St Kilda is a remote group of four small Atlantic islands (Hirta, Soay, Boreray and Levenish). Owned by the National Trust for Scotland and managed jointly with Scottish Natural Heritage, the archipelago has a host of conservation designations for its wildlife, geology and human history, including National Nature Reserve, World Heritage Site and candidate marine Special Area of Conservation. St Kilda has the highest cliffs and sea stacks in Britain, the most important seabird colony in Europe, unique island subspecies of wren and field mouse, and a feral flock of Soay sheep. The St Kildans, who lived there for at least 2,000 years, were evacuated in 1930. A small army base is now on the island.

Left The cold Atlantic waters around St Kilda nurture marine life as colourful as any tropical reef -- this photo really typifies St Kilda for me. The innocent, flower-like appearance of these carnivorous anemones is deceptive; a cliff covered in them is a death trap for smaller creatures swept in by the waves. *Nikonos V with 35mm lens and supplementary close-up lens, 1/90sec at f/16, Velvia 50, flash*

The scenery underwater is just as spectacular, and a great deal more colourful. The vertical cliffs and caves continue underwater to 98ft (30m) or more, the rock is covered with sheets of anemones and sponges in colours you wouldn't believe

For underwater close-ups, flash is essential both for light levels and to restore colours absorbed by the seawater. The flash must be separate from the camera so it can be placed above and at an angle to the subject, to avoid backscatter from particles in the water, especially important for wideangle. This means a separate waterproof flash, with watertight leads and connectors to the camera.

The only landing place is Village Bay on the main island of Hirta, where the St Kildans lived until their evacuation in 1930. You will want to photograph the old houses and cleits, which are small turfed storage huts. Climb the steep slope to the top of Conachair, behind the village, for a stunning view back to Village Bay, and an almost aerial one across to Boreray, 3.7 miles (6km) away. If the cloud base stays low there's scope for atmospheric shots of the 'main street', and for stalking the charming Soay sheep.

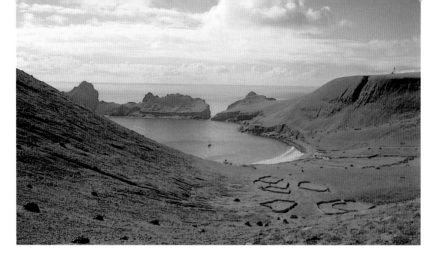

Above The view down into Village Bay encompasses all of the inhabited part of St Kilda, past and present. The concrete army base is small enough to be unobtrusive. But don't step back – behind is a 1,410ft (430m) vertical plunge into the Atlantic!
Nikon F-801s with 35–105mm lens, exposure details not recorded, Provia 100

Below On a grey day, a fast, grainy film emphasizes the lonely feel of the houses. Provia makes the most of the green and grey, while a 70–210mm zoom puts the rather flighty Soay lambs in the foreground.
Nikon F-801s with 70–210mm lens, exposure details not recorded, Provia 400

PLANNING

LOCATION
St Kilda is an island group 40 miles (65km) west of the Western Isles.

HOW TO GET THERE
Getting there can be difficult, the most usual options are by charter boat, private boat, National Trust working party or dive boat. The National Trust must be informed of your visit, tel: +44 (0) 1463 232034. For further information and advice visit www.kilda.org.uk or www.nts.org.uk

WHERE TO STAY
Cottages on Hirta are for National Trust working parties only. For further information see contact details above.

WHAT TO SHOOT
Underwater – spectacular cliffs and caves, seals, guillemots, colourful macro subjects. Above water – cliffs, seabirds, seals, spectacular viewpoints to the other islands, old buildings, Soay sheep, St Kilda wren and field mouse.

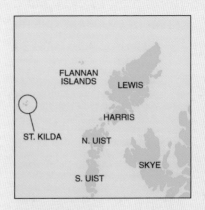

WHAT TO TAKE
Everything, and spares. More film than you think you will need; fast film and padded camera bags for the rolling boat; tissues to remove salt spray; windproof clothing; tripod to ward off great skuas; binoculars and anti-seasick pills.

BEST TIMES OF DAY
Underwater photography is best in the middle of the day, or whenever the sun is out. Or do a night-dive in Village Bay.

BEST TIMES OF YEAR
Only accessible in summer.

ORDNANCE SURVEY MAP
Landranger sheet 18

TEXTURES OF ROCKS AND SAND PATTERNS PROVIDE SUBJECTS
FOR SOME VERY ATTRACTIVE PHOTOGRAPHY AND PORT NESS,
ON THE ISLE OF LEWIS, MAKES AN IDEAL SETTING **NIALL BENVIE**

From a mainland perspective, the Port of Ness, or Port Nis, really is just round the corner from the back of beyond. But it all depends on where you're standing – to the people of Ness, their small village is the centre of things and it is the mainland to the east that seems remote.

The beach beside the harbour is flanked by low cliffs, above which stone houses brace themselves against the easterly wind. It is fascinating to me, not for any dramatic geological features, but purely for its sand and stone. My interest in the aesthetic qualities of sand and stone was fired in 1993 when I bought a paperback entitled *Crossing Open Ground*, by the American writer Barry Lopez. It was the cover illustration by Alan Magee (www.alanmagee.com) that truly captivated me. Not for the absolute realism of the pebbles in the painting so much as the extraordinarily delicate light he used. This wasn't realism for its own sake, rather a tactic to get the viewer to look hard at ordinary objects – because there was so much to see.

Above Taking advantage of the Hasselblad XPan's ability to focus quite closely, I was able to convey the sweep of the stream's action.
Hasselblad XPan with 45mm lens, 1/8sec at f/11, Velvia 50, centre spot neutral-density filter

Right I had to be quick to get the picture before the tripod sank! A polarizer removed surface reflection.
Nikon F5 with 17–35mm lens, 1/4sec at f/16, Velvia 50

Port Ness, Lewis

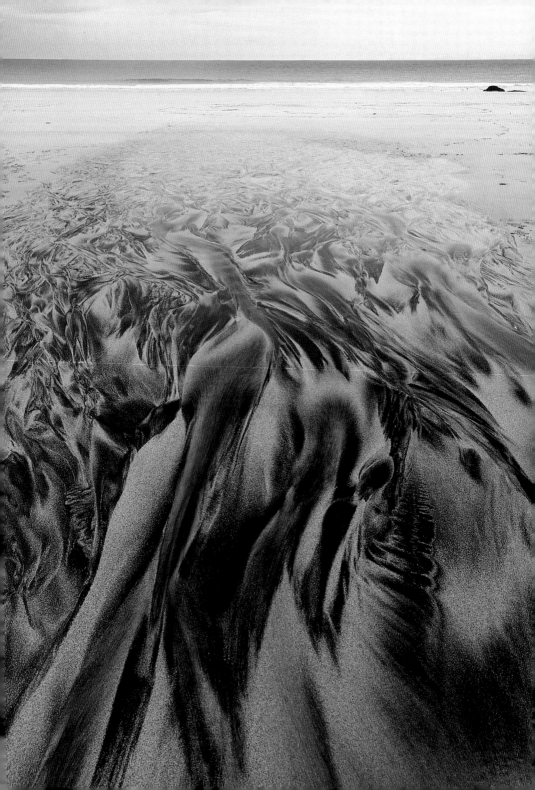

Ness's beach is perhaps its most alluring feature. The nearby 121ft (37m) brick-built Butt of Lewis lighthouse presents opportunities for creativity, but it is very hard to photograph well conventionally.

It was my travelling companion, Pål Hermansen, who called me over to look at the strange ripple patterns in the sand where a small stream was flowing. As it did so, pale sand was being washed away, revealing much darker sediment below. The chaotic flow of water caused the route of these channels to change constantly, creating a succession of new patterns. I minimized the familiar Western Isles elements of turquoise sea and shell sand, and instead gave prominence to the ripple patterns in the sand. A polarizing filter revealed detail below the surface sheen of the water.

I then spotted a water-smoothed stone protruding higher up the beach. Its clear linear bands were in opposition to the diffused lining in the sand around it, with that in turn cut across by a fine arcing band of accretion marking the extent of the sea's advance. I lit it with a diffuser on one side and a gold reflector on the other.

FACTS ABOUT:

Port Ness

Ness is perhaps best known as the departure point for the annual 'guga' hunt. Each August about ten 'Men of Ness' sail for Sula Sgeir, roughly 40 miles (25km) to the north of the Butt of Lewis, to harvest up to 2,000 young gannets. This practice has been going on since the 14th century. While it may have lost its importance in terms of providing winter protein for hungry residents, the tradition re-enforces community identity in this, the most northerly and most Gaelic parish in the Western Isles. The Scottish Executive issues a licence each year specifying the quota and killing method. The welfare group Animal Advocates condemns the hunt as 'brutal' and has, so far unsuccessfully, campaigned for the licence to be revoked. In light of the ever-growing population of gannets on Sula Sgeir and other North Atlantic colonies and lack of support from the main conservation groups, it's hard to see their campaign succeeding.

PLANNING

LOCATION

Port of Ness, or Port Nis, lies near the most northerly tip of the Isle of Lewis in Scotland's Outer Hebrides.

HOW TO GET THERE

The most direct ferry crossing is from Ullapool to Stornoway with Caledonian MacBrayne Ferries, tel: +44 (0) 8705 650000, www.calmac.co.uk. From Stornoway, take the A857 to its junction at Barvas with A858. Turn right, following the A857 to its end at the harbour in Ness.

WHERE TO STAY

There are accommodation listings at www.visithebrides.com, or contact the Scottish Tourist Board, details on page 190.

WHAT TO SHOOT

The 34-mile (55km) drive from Callanish to Ness passes some of the most impressive megaliths and archaeological remains in the UK.

WHAT TO TAKE

As well as your usual gear, take a disposable plastic sheet to protect your bag when you put it down on the beach. Bring the best waterproofs you have. A Gaelic-English dictionary will enhance your understanding of place names, if not their pronunciation.

BEST TIMES OF YEAR

Winter storms beating the coastline are exciting, but plan extra time on the island in case of delayed ferry sailings.

ORDNANCE SURVEY MAP

Landranger sheet 8

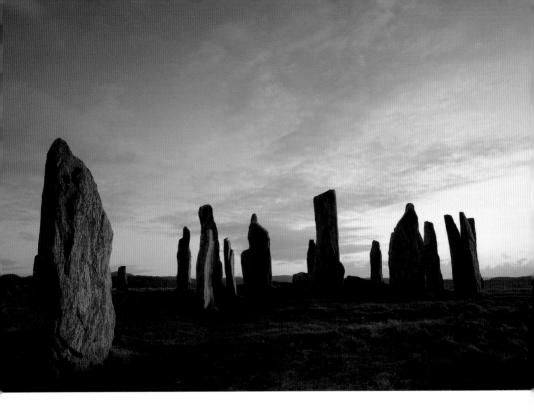

LEWIS WITH ITS RARE AND UNIQUE ARCHAEOLOGICAL SITES AND THE WILD, MOUNTAINOUS HARRIS ARE IDEAL TO EXPLORE IN ONE TRIP **DAVID WARD**

Although part of the same land mass, Lewis and Harris are very different islands each with a distinctive character. It is easy to explore both in one trip, perhaps starting in the bustling port of Stornoway and working down to the wild and mountainous Harris.

I was particularly drawn to the richness of archaelogical sites on Lewis and decided to photograph the 4,000-year-old neolithic Callanish Stones. Difficulty of access and a lack of publicity lead to places being overlooked, and this is certainly the case with the Callanish Stones.

Above The relationship between one stone on the edge of the group and the central cluster was particularly pleasing, giving depth to the composition. I realised I could place the bulk of the stones in shadow, with the foreground stone in the last rays of sunlight. *Technical details not recorded*

Lewis and Harris

They march across the horizon above a scattered crofting settlement, dominating the surrounding landscape. Up close the texture and patterning of the ancient Lewisian Gneis is fascinating. The stones almost seem to be made of driftwood, with pronounced grain and graceful organic shapes. The site is surrounded by a sheep fence topped with barbed wire which you are allowed inside though you are asked not to stray from the perimeter path.

Low-angle shots from the west of the stones allow one to exclude clutter, but don't provide the best angle for light falling on the stones. Late evening, sunset and beyond, gives the most atmospheric results but from the west the stones tend to be lit full on, giving a flattened perspective. This angle also tends to emphasize the long axis of the site, requiring a strong sky to give a third dimension.

Below left

Rock patterns, Bagh Steinigh, Isle of Harris. My friend discovered this wonderfully grained rock at low tide. We both spent some time shooting quite different images. The tonal and sculptural contrasts between the light central outcrop and the sea-rolled darker boulders give an inherent strength – it's just a question of finding a viewpoint! I left the photograph unfiltered to give a slight blue tinge to the central rock. *Linhof Technica 5x4 with 150mm lens, 1/2sec at f/27, Velvia 50*

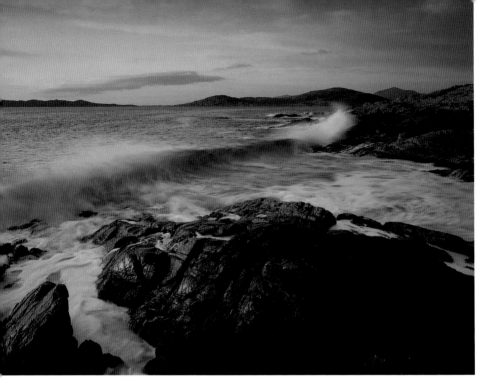

Above Rubha Romagi, Harris. I wanted to capture the light shining through the wave top and the golden reflection on the rocks. A faster shutter speed may have been better, but the limitations imposed by large-format on depth of field precluded this. I compromised at *1/4sec*, giving me definition in the wave and a sense of motion and light.
Linhof Technica with 90mm lens, 1/4sec at f/27, Velvia 50, 2-stop neutral-density graduated filter

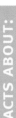

FACTS ABOUT:

Callanish

The 4,000 year old standing stones of Callanish stand outlined against the sky on a promontory overlooking Loch Roag. They are the centrepiece of a complicated group of standing stones stretching for several miles across the surrounding hills. The stones were erected in several phases and now form the pattern of a Celtic cross in plan, though they predate Christianity by several thousand years. There are many legends and myths attached to the stones; one I particularly like is that they are enchanted, and that you cannot count them because the number you arrive at will always be different.

PLANNING

LOCATION
Loch Roag, Isle of Lewis,
Outer Hebrides.

HOW TO GET THERE
Caledonian MacBrayne provide
ferry services to Lewis from Ullapool
or alternatively via Uig on Skye to
Tarbert on Harris, tel: +44 (0)8705
650000, www.calmac.co.uk, for
further information. It is also
possible to fly to Stornoway via
Inverness or Glasgow. If flying into
Stornoway, car hire is available at
the airport. Callanish is situated in
the south-west of Lewis, with free
parking at the visitor centre.

WHERE TO STAY
Doune Braes Hotel
tel: +44 (0) 1851 643252,
www.doune-braes.co.uk, is
recommended. For full listings see
www.visithebrides.com or contact
the Scottish Tourist Board, details
on page 190.

WHAT TO SHOOT
There are opportunities for detail
studies of the patterns on the
stones and wider views. Harris has
some stunning mountainscapes
and machair plains.

WHAT TO TAKE
All-weather gear – it's often cold
and windy. A tripod is essential,
not only because of the wind, but
also to get the most from low-light
level conditions.

BEST TIME OF DAY
Sunset or after for photographing
the stones of Callanish.

BEST TIMES OF YEAR
The stones are sufficiently
sculptural for strong images at
any time of year. Winter can be
particularly spectacular with snow
clinging to the stones and low light
all day long.

ORDNANCE SURVEY MAP
Landranger sheet 13

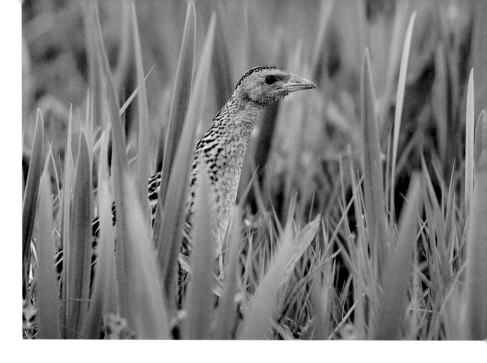

NOT ONLY A BIRDWATCHERS' PARADISE, NORTH UIST OFFERS A STUNNING BLEND OF BEACHES, MOORLAND AND AN INTRICATE PATCHWORK OF FRESHWATER LOCHS **MARK HAMBLIN**

My decision to make the trip to North Uist was based purely on a desire to photograph the elusive corncrake which is held in high regard among birdwatchers and bird photographers alike. However, North Uist offers a lot more than just corncrakes and, with a plethora of breeding waders and many other birds, it rates as one of the best places in Britain for bird photography. North Uist has not suffered the agricultural changes that have taken place elsewhere, largely due to traditional crofting methods. Throughout the Uists, corncrakes can find suitable habitats in which to breed.

One of the main problems for photography is the corncrake's liking for thick cover, making them extremely hard to spot. They are, however, much easier to hear as they have a loud rasping call which

Above Using my car as a mobile hide and playing a tape of a calling male corncrake, I was able to draw this alert and curious specimen from his hiding place for a few seconds, just long enough to take three frames. *Canon EOS 3 with 500mm lens, 1/500sec at f/5.6, Sensia 100*

North Uist

North Uist is renowned for its wildlife. Breeding birds include the elusive corncrake, dunlin, ringed plover, oystercatcher, lapwing, redshank, snipe, golden eagle, red-throated diver, greylag goose and short-eared owl. Every year around 9,000 grey seal pups are born on the Monach Islands off the west coast of North Uist – the largest breeding colony in Europe. The island is a place of great contrasts. The smooth tidal sand flats of Vallay Strand, Grenitote and those that surround Baleshare Island balance the jagged coastline to the north of Lochmaddy. On the west side of the island lies the fertile and flower-rich machair from which you may be able to catch distant views of St Kilda. Fewer than 2,000 people make North Uist their permanent home today, though in the past there were more than double that number.

Right Although largely devoid of woodland, well-established gardens on the island provide good habitat for a wide range of birds, including song thrushes. This male was seen singing from a number of song posts but none was especially photogenic. This post was therefore set up in a sunny position with an uncluttered background. I took the shot from the car, resting the lens on a beanbag.
Canon EOS 3 with 500mm lens, 1/500sec at f/5.6, Sensia 100, beanbag

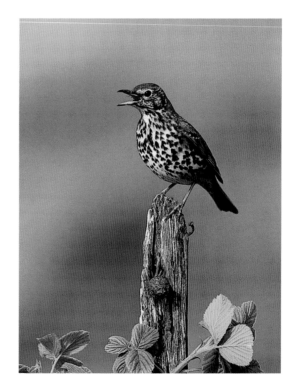

Below The machair habitat is perfect for rabbits which are present on North Uist in large numbers. A west-facing warren provided me with a great opportunity to photograph late into the evening when the rabbits were most active. It also had the bonus of good access for a car, which I used as a mobile hide. When these two youngsters first emerged they greeted each other by rubbing noses.
Canon EOS 3 with 500mm lens, 1/250sec at f/5.6, Sensia 100

echoes from the iris beds throughout the summer. The best chance for photography is when these migrants first arrive back in early May. At this time of year the iris beds provide the incoming corncrakes with the only possible cover.

I visited all the potential stretches of habitat by car, some of these were close enough to the road to allow me to use the car as a mobile hide. I also tried using a portable canvas hide, but this proved too restrictive and I found the car worked much better. I used a technique of tape-lure to attract the birds. The use of sound recordings to attract birds is a contentious issue. My own view is that when performed in a responsible manner, in short bursts, it has minimal effect on breeding individuals, as most birds lose interest within a few minutes. In an attempt to attract a corncrake to within photographic range, I played the tape of a calling male from the car in short bursts for a minute or so. On the occasion I shot the main picture, page 152, a corncrake came straight towards me after the first burst from the tape.

PLANNING

LOCATION

North Uist is one of the principal islands that make up the Outer Hebrides in north-west Scotland.

HOW TO GET THERE

Travel to Skye via the bridge at Kyle of Lochalsh and take the A850 across the island to the Uig. Then take the Caledonian MacBrayne ferry to Lochmaddy on North Uist. For timetables and bookings: tel: +44 (0) 8705 650000, www.calmac.co.uk

The islands of Benbecula and South Uist, linked to North Uist by causeways, are equally productive for breeding birds, including the elusive corncrake.

WHERE TO STAY

A range of hotels, B&Bs and self-catering accommodation exists on North Uist. There is also a hostel at Claddach Baleshare, tel: +44 (0) 1876 580246. Struan Cottage (self-catering) at Sollas charges is a typical Hebridean thatched cottage, e-mail: drdmacaulay@hotmail.com. For full listings, contact the Scottish Tourist Board, details on page 190 or see www.visithebrides.com

WHAT TO SHOOT

Breeding birds from the roadside. Rabbits on the machair, seals, otters, flowers, coastal scenes.

WHAT TO TAKE

A 500mm lens for shooting birds from a vehicle. A window platform or beanbag. Scrim netting to cover the car window and provide camouflage. A portable hide would also be useful.

BEST TIMES OF YEAR

May is the optimum month for photographing corncrake as well as breeding waders and other birds. June and July especially are ideal months to see colourful flowers on the machair.

ORDNANCE SURVEY MAP

Landranger sheets 18 and 22

THIS IS AN IDEAL PLACE TO WITNESS SPECTACULAR FLOWERING MACHAIR PLAINS, ONE OF THE RAREST HABITATS IN EUROPE, SET AMONGST A SCENIC JIGSAW OF LAND AND WATER **SUE SCOTT**

The main road running from north to south along South Uist neatly divides the island into 'blacklands' (acid moorland and mountains) to the east, and more fertile, sandy machair to the west. Every ice-scoured hollow is filled with water; in the east, peaty-dark and often covered with water lilies, while the machair lochs to the west are clear and shallow with a wide assortment of waterweeds. Most of the small side roads west of the main road will take you across the machair, ending on a ridge of dunes, which hides miles of long sandy beaches.

Machair is a Gaelic word meaning an extensive, low-lying, fertile plain. It is also used in a more specific way by biologists to describe a cultivated coastal dune pasture, usually fertilized by blown shell sand, developed in wet and windy conditions. Machair is one of the rarest habitats in Europe, with the most extensive areas in the Uists, Barra and Tiree.

There is no shelter in the open, treeless landscape of South Uist, and there's not a lot you can do in horizontal rain and a force 10 gale. But as soon as the

Above I wanted only the essential elements of windswept flowers and sky. A suitable viewpoint was chosen among the dunes, and a polarizer used to enhance the blue sky and reduce reflection from the shiny buttercups. I took around 15–20 shots with different shutter speeds, to get varying amounts of movement in the flowers. *Nikon F-801s with 20mm lens, exposure details not recorded,*
–1-stop exposure compensation,
Provia 100, polarizer

Howbeg

Although there is a generally accepted custom of open access to unfenced land in Scotland, remember that the machair is working croftland. Avoid disturbing farm animals and breeding birds (mainly ground-nesting on Uist, so watch where you walk). Also avoid walking on areas which are under cultivation, and keep vehicles on existing tracks. A few sections of the machair and coast are used by the military for training – avoid areas with red flags.

Expert Advice

June and July are the best months to visit South Uist, when large areas of the machair are an amazing carpet of colourful small flowers, and the air is full of bird calls. Strips of land, ploughed the previous year, are covered with yellow violas, tiny pink geraniums, blue forget-me-nots, white daisies, purple bugloss, red poppies and many flowering plants. Older pasture in early summer will have bright yellow buttercups and bird's foot trefoil predominating, while later there are more red, pink and purple flowers, particularly red clover and ragged robin. Orchids are abundant everywhere.

sun comes out, you will want to dash out to capture stunning skyscapes, and the ever-changing light reflecting from the myriad lochans and surrounding sea. Showery weather, although irritating to work in, can produce wonderful light, colours and cloud formations. If you are lucky with a windless day, a slow film or low digital ISO rating will pay dividends with the colours. A mass of colourful flower heads blurring in the wind can also give a nice sense of movement. For landscapes you will need a sturdy tripod and a faster film, or higher ISO. A beanbag can be useful for low viewpoints, which you will almost certainly want to take.

I was lucky to join a bus tour that had permission to drive up to a hilly viewpoint not usually accessible to the public, picture on page 158. There are other places on South Uist where there are similar or even better vistas, from higher elevations, although you will have to do it the hard way. The effort is well worth it – the panoramic jigsaw of land and water, in almost equal amounts, is quite extraordinary.

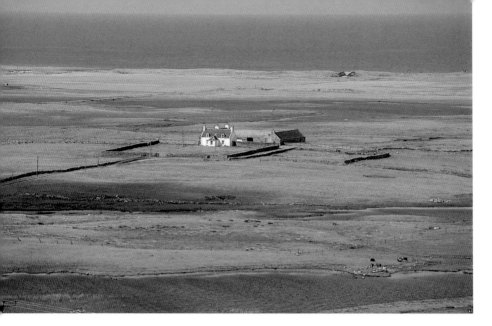

Above This croft, alone in the green and blue of a freshly rain-washed machair landscape, conveys peace and isolation; no hint that it was actually taken on an organized bus tour. Provia has made the most of the predominant green and blue, while a polarizer cut through the water reflections, and avoided an over-exposed white house.
Nikon F-801s with 70–210mm lens, exposure details not recorded, Provia 100 downrated −1/3 stop, polarizer, handheld

Below I couldn't resist this football pitch covered with daisies. Apart from the goalposts and a few worn patches, it's indistinguishable from the rest of the machair.
Nikon F-801s with 20mm lens, exposure details not recorded, −1-stop exposure compensation, Provia 100, polarizer

PLANNING

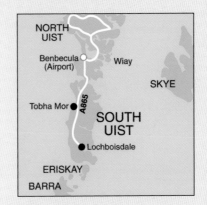

LOCATION
Howbeg is on the west coast of South Uist, in the Western Isles.

HOW TO GET THERE
By ferry from Oban, Argyll to Lochboisdale, or from Uig, Skye to Lochmaddy. Caledonian MacBrayne Ferries tel: + 44 (0) 8705 650000, www.calmac.co.uk. There are also scheduled flights from Glasgow to Balivanich on Benbecula.

WHERE TO STAY
The Orasay Inn, Lochcarnan (about 10 miles/16km from Howbeg) has excellent food and comfortable accommodation, tel: +44 (0) 1870 610298. B&Bs on South Uist are good value, for full listings check www.visithebrides.com or contact the Scottish Tourist Board, details on page 190.

WHAT TO SHOOT
Skyscapes, land and waterscapes, beaches, crofting, flowers, birds.

WHAT TO TAKE
Everything you need, and spares – there are no photo shops. Sturdy tripod, beanbag, windproof and waterproof clothing and camera bags, something waterproof to lie on, polarizers, graduated filters, binoculars and vacuum flask.

BEST TIME OF DAY
Anytime it's not raining! Sunsets and sunrises are definitely worth the effort; the light can be flat in the middle of the day but varies enormously depending on the weather.

BEST TIMES OF YEAR
Late spring and early summer are good for birds; autumn for sunsets, seashores and skies, and maybe a show of the northern lights.

ORDNANCE SURVEY MAP
Landranger sheet 22

WITH ITS WILD, MOUNTAINOUS INTERIOR SURROUNDED BY STRETCHES OF PRISTINE WHITE SAND, BARRA IS ONE OF THE MOST ATTRACTIVE OUTER HEBRIDEAN ISLANDS WITH A PRECIOUS ATMOSPHERE OF PEACE AND SOLITUDE **LYNNE EVANS**

Above This shot of Tràigh Eais taken late in the morning captured the essence of being alone in a beautiful and tranquil place. The light cloud provides gentle movement in what could otherwise have been a fairly static image. *Mamiya 645 with 45mm lens, 1/8sec at f/19, Velvia 50, tripod*

Barra

I came to Barra on a typical 'driech' day, arriving by ferry at Castlebay, the island's main harbour town. After a couple of days of exploration I discovered Tràigh Mhór, towards the northern end of the island, an eastward-facing bay of white shell sand, famous for its tidal airstrip. Its strength photographically is that, no more than 400 yards away, there is an equally impressive west-facing bay, Tràigh Eais. Tràigh is the Gaelic word for beach.

Apart from great photo opportunities, one thing I enjoyed on the Western Isles was the solitude and sense of peace that pervades the islands. I spent many hours taking long contemplative walks on deserted beaches, and it was on one such walk that I decided to try to capture these sentiments with my camera. At around 11am the sun was high, not generally the most sought-after lighting condition, but the air was clear and there was none of the haze which can have such a deadening effect in midsummer. The incoming tide was presenting the waves in a steady rhythm and the water itself was a clear turquoise over the white sand.

FACTS ABOUT:

Barra

Together with Vatersay, Barra is the southernmost inhabited island of the Outer Hebrides. It is 7 miles (11.3km) wide and 8 miles (12.8km) long, but boasts some 1,000 species of wild plants and over 150 species of birds. The topography is mixed, with a rugged mountainous interior and mainly rocky east coast, but stunning sandy beaches and areas of machair on the west and north coasts. The current population of Barra and Vatersay is in the region of 1,100 people. At the north end of Tràigh Eais, at Dun Scurrival, there is a prehistoric fort. This provides an excellent vantage point over both bays to the south and northwards across the Sound of Barra to Eriskay and South Uist.

Above Sunset from the headland south of Tràigh Eais. At 9pm there was no hint of a spectacular sunset, then over the next two hours the clouds changed, the colour materialized and became more and more dramatic. This shot was taken around 10.30pm. I was still photographing at 11.15pm.
Mamiya 64 with 80mm lens, 20secs at f/22, Velvia 50, tripod

The simplicity of the scene belies the attention to detail that goes into making an image like this. A tripod and spirit level were essential to ensure the horizon was perfectly level. I let the scene and colours take control of the image in their natural state. The final element was the timing; I wanted definition in the wave without a mass of white foam. Fortunately the waves were fairly evenly spaced, so with careful watching I succeeded in making the exposure at exactly the right time.

Evening found me yet again on Tràigh Eais, the windward side of the island, backed by large, steep-faced dunes. Things still did not seem to be coming together as the sun dropped towards the horizon, and I challenged myself with a climb to the top of the dunes through stabbing marram grass. At last I had found my composition, with the low sun reflecting from the marram leaves, enough clouds to give the sky some interest and a distant view of Dun Scurrival to the north.

PLANNING

South
Uist

Barra

LOCATION
Barra is the most southerly inhabited island of the Outer Hebrides.

HOW TO GET THERE
The island is served by Caladonian MacBrayne ferries running regularly from Oban and Lochboisdale (South Uist) into Castlebay, tel: +44 (0) 8705 650000, www.calmac.co.uk. Another ferry links Ard Mhor in the north of the island to Eriskay. There are also regular flights from Glasgow airport. Tràigh Mhor and Tràigh Eais are located at the northern end of Barra. Leave the A888 on the minor road signposted to the airport.

WHERE TO STAY
There is free camping at Tràigh Mhor. Numerous B&Bs around the island. Hotels at Castlebay and the Isle of Barra Hotel at Tangasdale Beach, tel: +44 (0) 1871 810383. For full listings contact the Scottish Tourist Board, details on page 190, or go to www.visithebrides.com

WHAT TO SHOOT
Landscapes, seascapes, birds and wildlife and the wild flowers of the machair. The impressive Kisimul Castle in Castlebay, home of the ancient MacNeil clan.

WHAT TO TAKE
Usual photographic gear, especially tripod, graduated filters and polarizer. Windproof clothing. Camper van particularly useful as few facilities on the island!

BEST TIMES OF YEAR
Spring and summer for the best light and most stable weather conditions.

ORDNANCE SURVEY MAP
Landranger sheet 31

ONE OF THE MOST PHOTOGRAPHED VILLAGES ON THE ISLE OF
SKYE, ELGOL IS A SUPERB PLACE TO CAPTURE THE MOODY CUILLIN
RIDGE AND ROCKY SHORES OF THE HEBRIDES **ANDY LATHAM**

The view from the harbour at Elgol on the Isle of Skye across Loch Scavaig, towards the mighty Cuillin, is arguably the finest in Britain. Having found an apartment overlooking the harbour, I knew that in April the sun would set just to the left of the Cuillin and would therefore strike the shore perfectly. However, was the view from Elgol too famous? This location has been the subject of wonderful photographs by such landscape giants as Colin Prior, Paul Wakefield and Joe Cornish. How could I possibly produce anything new, let alone worthy? Fortunately, common sense prevailed. Just because somewhere has been photographed before it doesn't mean there's no point trying yourself. There are infinite

Above The long exposure has given an ethereal feel to the sea, which is set against the menacing mountains and clouds.

Mamiya 7II with 65mm lens, 8secs at f/22, Velvia 50, 81C warm-up filter, 2-stop soft neutral-density graduated filter, tripod

Elgol, Skye

combinations of the weather, tide and play of light, and there will always be something new, provided you are patient and prepared to look hard enough.

The classic view of the Cuillin is usually taken from the rocky beach, in front of the village school, and often includes the attractive honeycomb cliff at its northern end. A small spur, accessible except at high tide, juts out from the base of the cliff and can be used for good foreground interest. My first evening was spent here, shooting the sun setting behind Soay and to the left of Gars-bheinn, the southern peak of the Cuillin ridge.

Part of the magic of Elgol for me is the great variety of rock along the coastline. In just a short space, you can pass from sandstone shelves, to limestone clints, to a rough beach of boulders.

Below Gorgeous light bathes the rocks a little to the north of the honeycomb cliff, a soft neutral-density graduated filter was used to retain detail in the sky. *Mamiya 7II with 65mm lens, 2secs at f/22, Velvia 50, 81B warm-up filter, 2-stop soft neutral-density graduated filter, tripod*

Different rocks produce different pictures and the tide constantly highlights varying features. My lens, though, was constantly trained upon the awesome line of the Cuillin ridge, an impregnable fortress across the seemingly benign waters of Loch Scavaig.

The main image (page 164) was taken a short distance along the coast to the south of the harbour. While exploring the tide line I was drawn to the plate-like rocks, which provided yet another variation for the foreground. However, the picture wouldn't have been worth taking were it not for the faint band of colour in the sky which perfectly highlighted the jagged teeth of the mountain ridge. I selected a viewpoint that would include an area of rock that was being washed over by the tide, to provide some movement in a very calm sea. I love the silky ethereal effects that long exposures of the sea can produce.

Elgol is a truly breathtaking location and is worth every effort to visit. Just make sure that you grant it sufficient time to fully appreciate its splendour.

FACTS ABOUT:

Elgol

Elgol is a small crofting and fishing village at the southern tip of the Strathaird peninsula on the Isle of Skye. It commands wonderful views of the main Black Cuillin ridge, Bla Bheinn in the Red Cuillin, and the islands of Soay, Canna and Rhum. Relatively isolated at the end of a long single-track road from Broadford, it is a nature lover's paradise. Otters and porpoise can be seen near the harbour and it is the start of the classic coastal walk to Loch Coruisk via Camasunary. The less energetic can opt for the boat trip to Loch Coruisk and view the seal colonies. The immediate area around Elgol is of geological and historical interest – Bonnie Prince Charlie is reputed to have hidden in a cave to the south of the village after he fled the mainland following the disastrous Battle of Culloden over 250 years ago.

PLANNING

LOCATION
At the end of the Strathaird peninsula, 14 miles (22.5km) from Broadford, on the Isle of Skye.

HOW TO GET THERE
Across the Skye Bridge, turn left at Broadford along the B8083 and continue until you meet the sea. A limited postbus service is available from Broadford.

WHERE TO STAY
The Pier House is a self-catering apartment for two and sits above the pier with probably the best views in the country, tel: +44 (o) 1471 866259, or visit www.gael.net/pierhouse. For other self-catering and B&B options available in the village, go to www.skye.co.uk or contact the Scottish Tourist Board, details on page 190.

WHAT TO SHOOT
The view of the Cuillin, the Isle of Rhum, wonderful coastline, fishing boats in the harbour, otters and porpoises if you are lucky.

WHAT TO TAKE
Usual photographic equipment.

BEST TIME OF DAY
Mornings for light on the Cuillin, evenings for light on the shore.

BEST TIMES OF YEAR
Scotland is always at its best outside the summer months.

ORDNANCE SURVEY MAP
Landranger sheet 32

SKYE PROVIDES PLENTY OF PHOTOGRAPHIC OPPORTUNITIES WITH ITS DRAMATIC MOUNTAIN AND MOORLAND LANDSCAPES DOTTED WITH CHARACTERFUL COTTAGES **DUNCAN MCEWAN**

Celebrated in song, poetry, music and art, the Isle of Skye fully deserves its romantic reputation. It is the largest of the Inner Hebridean Islands and contains everything that mainland Scotland has to offer the landscape photographer. Sligachan, the location of the main picture shown above, lies 25 miles (40km) from Kyleakin in the south of the island.

The old cottage can hardly be missed as it is situated at the side of the Sligachan to Dunvegan road. The building itself is no beauty, with grey concrete walls, but the rusty red corrugated roof can be eye-catching. The location, however, more than makes up for any limitation in the cottage itself, with wild moorland stretching in one direction to the rounded Red Cuillin mountains, and in the other to the jagged, rocky peaks of the Black Cuillin.

Above I used a polarizing filter, partly to deepen the blue of the sky and emphasize the cloud, but also to intensify the rusty red colour of the roof. I took care not to over-polarize, however, otherwise an unnaturally saturated image would have resulted.
Technical details not recorded

It was while having a bite to eat that I suddenly saw the small, white cloud appear in an almost cloudless sky. Lunch was abandoned, camera quickly mounted on a tripod and the scene carefully framed up to portray the three main elements of cottage, mountains and cloud. The triangular shape of the cottage gable is an echo of the shape of Glamaig, the mountain on the left. Fortunately, the light was not catching the gable end, and this area of shadow has created a degree of contrast that helps give a sense of depth to the scene. It was important to avoid the apex of the cottage being directly beneath the peak of the mountain, which would have been the case had I been further to the right. The cloud seemed perfectly positioned in the cleft between the peaks.

Below The subtle quality of dawn light is seen here from Isleornsay on the Sleat peninsula looking across to the mainland mountains of Knoydart. Positioning the lighthouse on the central axis was necessary to maximize the shape and lighting of the mountain. *Minolta Dynax 9 with 28–135mm lens, 1/60sec at f/11, Sensia 100, tripod*

Left Situated 15 miles (24km) from Broadford, Elgol provides rocky shores and eroded cliffs as foregrounds for views of the Black Cuillin on the other side of Loch Scavaig. Midday sun reflecting off the rock slabs beneath reflected sufficient light on to the overhanging cliff.
Mamiya RZ67 with 50mm lens, 1/30sec at f/22, Velvia 50, tripod

The Isle of Skye

Although over 600 square miles (1,554sq.km) in area, no part of Skye is more than 5 miles (8km) from the sea due to its peculiar amoeboid shape. Roads are good, but it takes a deceptively long time to travel and explore the long peninsulas. For walkers and climbers, the few restrictions on access exist mainly during the autumn deer-stalking season. There are red deer, seals, otters, golden eagles, sea eagles, buzzards, herons as well as moorland birds and seabirds. Many rare Arctic and alpine plants can be found on the higher slopes. Weather on the 'misty isle' can be variable at any time of year but this is part of the attraction for the photographer. Good visitor attractions include the Aros Experience (Portree), museums and the famous Talisker Distillery.

PLANNING

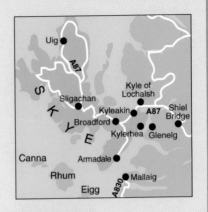

LOCATION
The Isle of Skye is off the West coast of Highland Scotland.

HOW TO GET THERE
By toll bridge from Kyle of Lochalsh; by Caladonian MacBrayne ferry, tel: +44 (0) 8705 650000, www.calmac.co.uk, from Mallaig to Armadale; by ferry from Glenelg to Kylerhea (summer only). All routes lead to Broadford, Sligachan is 17 miles (27.3km) beyond.

WHERE TO STAY
There are plenty of B&Bs, bunkhouses and hotels on Skye. Sligachan Hotel and camping site, tel: +44 (0) 1478 650204, www.sligachan.co.uk, are only two miles from the main picture. For full listings visit www.skye.co.uk or contact the Scottish Tourist Board, details on page 190.

WHAT TO SHOOT
Mountainscapes, rocky shores and cliffs, white-washed fishing villages and wildlife.

WHAT TO TAKE
Clothing for all weathers, plenty of food and drink, insect repellent (June to August) and stacks of film.

BEST TIMES OF DAY
Midday to evening for the cottage, morning to midday at Elgol and Isleornsay. There is always something to photograph at any time of day.

BEST TIMES OF YEAR
May, September and October are favoured – no midges!

ORDNANCE SURVEY MAP
Landranger sheet 32

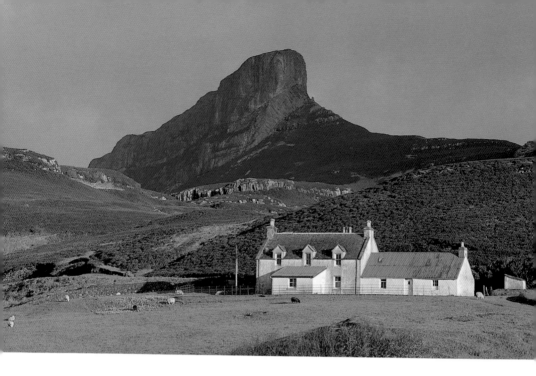

EIGG IS A QUIET YET DRAMATIC ISLAND WITH ITS TRADITIONAL WAY OF LIFE WELL PRESERVED. VISITORS ARE GIVEN A WARM WELCOME TO ENJOY THE PEACE AND TRANQUILITY **NIALL BENVIE**

The laws concerning land acquisition are somewhat more lax in Scotland than in other parts of Europe. If you have enough money to out-bid your competitors, you can easily acquire an estate or island. The island of Eigg has had more than its fair share of custodians unable to meet the challenges of ownership, and the community of 70 islanders has seen its hopes raised and dashed many times in the past. But in June 1997 all that changed when the community, in partnership with the Scottish Wildlife Trust (SWT), succeeded in buying the island from its then owner. The islanders, in co-operation with the trust, have risen to the challenge: the dereliction of the past is gradually disappearing and there is a new mood of optimism.

Above I arrived just as the sun spread over the scene, leaving the Sgurr in ominous shadow. I metered off the heather to the left of the house for my midtone, then underexposed by half a stop to prevent the lime-washed house from losing any detail in its highlights. *Technical details not recorded*

Eigg

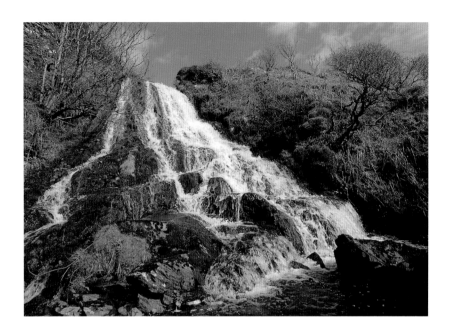

Above Waterfall below Blar Dubh. While I was walking towards Laig Bay one day, I heard the sound of running water near the road and climbed down to this attractively shaped waterfall. To make it look higher, I chose a low viewpoint and a very wide lens.
Nikon F4 with 20mm lens, exposure details not recorded, Velvia 50, tripod

The roads of Eigg were not designed for anything other than very light traffic and car use is restricted. If you want to get around Eigg easily, bring a mountain bike with you on the boat. The island is small enough to cycle around comfortably, but there are a few steep hills. Travelling by bike will also allow you to appreciate another local curiosity. Just about every house has a generator muttering away in a wooden outbuilding; Eigg is not connected to the National Grid, nor does it have mains running water.

Although most of the island is farmed, much of it has a wild feel, a sensation heightened by the proximity of Rum's sawtoothed silhouette. The beach at Laig Bay offers some of the most spectacular views of Eigg's neighbour, especially at sunset. The skyline of Eigg is defined by An Sgurr ('Scoor'), an extravagant pitchstone ridge at its most dramatic when viewed from the east side of the island.

West coast weather is notoriously fickle, although May is normally more settled. I had to wait until my

last morning, however, before I got the attractive early light I needed for the composition I'd spotted a couple of days earlier. I started to make my way there well before breakfast and arrived just as the sun spread over the scene, leaving the Sgurr in ominous shadow. I metered off the heather to the left of the house for my midtone, then closed down by half a stop to prevent the lime-washed house from losing detail in its highlights.

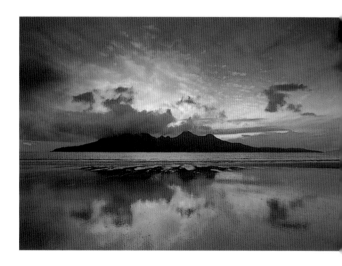

Right Rum from Laig Bay. When it looked like there would be a colourful sunset, my host drove me up to this bay. The colours weren't especially vivid so the results with saturated film looked quite natural. *Nikon F4 with 28mm lens, exposure details not recorded, Velvia 50, 2-stop neutral-density graduated filter, tripod*

FACTS ABOUT: Eigg

Before the community buy-out, one of the problems the islanders faced was insecurity of tenure, without which it was not possible to obtain local authority grants for property repairs. Nor was there the incentive to undertake repairs independently. As a result, many buildings suffered dilapidation, something which is now being put right. Nevertheless, there is still a wonderful collection of vehicles in advanced states of decay and disassembly plying the roads of Eigg and, since removal from the island is a logistical nightmare, others are simply abandoned.

PLANNING

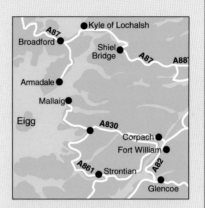

LOCATION
Eigg lies about 10 miles (16km) to the west of Arisaig, south of Skye, on Scotland's west coast. The island is about 5 miles (8km) end to end and 3.5 miles (5.6km) wide.

HOW TO GET THERE
Ferries to Eigg leave from Mallaig (Caledonian MacBrayne, tel: +44 (0) 8705 650000, www.calmac.co.uk) and Arisaig (Arisaig Marine, tel: +44 (0) 1687 450224, www.arisaig.co.uk). Use of cars is restricted on Eigg. For further information go to www.isleofeigg.org

WHERE TO STAY
Kildonnan House, is highly recommended, tel: +44 (0) 1687 482446 but book well in advance as accommodation on the island is quite scarce. For other options go to www.isleofeigg.org or contact the Scottish Tourist Board, details on page 190.

WHAT TO SHOOT
As well as impressive views of Rum, there are some lovely hazel woodlands at the back of Kildonnan Bay, choked in May with ramsons and bluebells. The bryophyte flora is rich and otters are present, although I didn't see any on my visit. Among the plants I found, limestone bugle was a special rarity. Look for manx shearwaters and cetaceans on the crossing.

WHAT TO TAKE
A bike is essential if you want to be able to get around quickly. A taxi service is available. Being the west coast, you'll never go wrong with waterproofs.

BEST TIMES OF YEAR
It might be best to stick to the summer months when the sea is likely to be less wild.

ORDNANCE SURVEY MAP
Landranger sheet 39

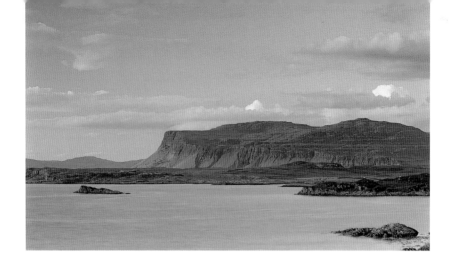

MULL IS POPULAR WITH WILDLIFE AND WALKING ENTHUSIASTS
WHILE OTHERS ENJOY THE JAUNTY CAPITAL OF TOBERMORY OR THE
NEIGHBOURING SPIRITUAL ISLE OF IONA **ANDREW PARKINSON**

As is so often the case with my photography what I plan to do and what I actually end up doing are usually poles apart. A visit to Mull proved to be a perfect example of this. A week of wildlife photography is what was planned; a week of landscape photography is what transpired. That elusive action-packed, talons-outstretched, pin-sharp shot of a white-tailed sea eagle just never happened.

Photographic delusions aside, this spectacular seabird was one of the reasons why I decided to go to Mull. And it was to catch a glimpse of this majestic hunter that led us first to Grasspoint, a small peninsula off the A849 just south of Craignure, a well-documented hot spot for eagle viewing. But we would almost certainly have left without a sighting had it not been for the intervention of one of Mull's wildlife guides, who arrived soon after we did. Within minutes the show was over and he left as abruptly as he'd arrived, pointing out some adders as he went. We headed west along the A849 towards Pionnophort and the Isle of Iona to the pristine shores of Loch

Above Loch Scridain.
Nikon F90X, 80–200mm lens, 10secs at f/11, Velvia 50 rated at ISO 40, 3-stop neutral-density graduated filter, tripod

Right A short way from the road I was struck by the variety of colour in this scene. By using the hyperfocal scale on the lens and with a quick check on the depth-of-field preview I was able to achieve full sharpness at f/11. *Nikon F90X with 28mm lens, 1/4sec at f/11, Velvia 50, polarizer*

Below Looking back over Loch Scridain. *Nikon F90X with 28mm lens, 1sec at f/22, Velvia 50, polarizer and 3-stop neutral-density graduated filter*

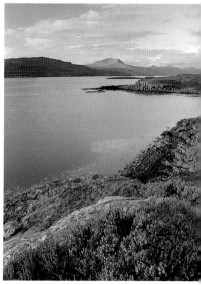

Above I have been reliably informed that this effect is known as cock-horn and is usually caused by a knock to the horn when the animal is young. It causes the animal no distress but makes an interesting portrait. *Nikon F90X with 300mm lens, 1/250sec at f/4, Provia 100*

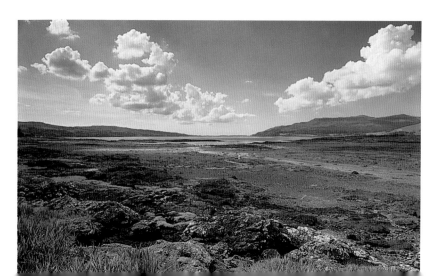

177

Mull

For those with a head for heights and lots of energy, Mull has the only island munro (mountain over 3,000ft/914m) outside Skye. Apparently the views from the top are worth it but be warned, most routes start from near sea level so it's a good climb. Recently reintroduced to the UK, and with continuing pressure from unscrupulous egg collectors, the white-tailed sea eagle is an extremely vulnerable species that requires and receives the highest level of protection.

Scridain, a coastal loch that characterizes perfectly all that is special about the island. Its fringes, warmed by the Gulf Stream, teem with an abundance of wildlife, as otters, seals and all manner of wading birds feast on the rich marine bounty.

The main image, page 176, was taken from a craggy outcrop overlooking the loch, about two to three miles past Bunessan and only about 50 yards from the road. As we neared the top, I could see that with most of the foreground already in shadow too much of the picture would be rendered a featureless black. Opting for an 80–200mm lens I knew that I could eliminate the foreground and concentrate the image on the distant scree slopes now already bathed in glorious evening light. To balance the image further I used a three-stop neutral density graduated filter to try and retain detail in the sky. Meanwhile a gusty evening wind had picked up, making camera shake, with the optical length selected, almost inevitable. As the light began to fade I removed the lens hood and anchored the tripod legs with my camera bag. In a last attempt to get a sharp image I persuaded my girlfriend to position herself next to the tripod, jacket pulled open, to act as a makeshift windbreak. It is ironic that the image you see here seems to convey a feeling of warmth and tranquility.

Expert Advice

A week was really only just enough time to scratch the surface of what Mull has to offer. As the largest of the Inner Hebrides it is everything that the aspiring wildlife or landscape photographer could possibly wish for.

PLANNING

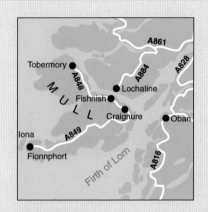

LOCATION
Mull is an island off the west coast of Scotland and is the largest of the Inner Hebrides.

HOW TO GET THERE
A85 to Oban then by ferry to Craignure. Alternatively, via the Corran ferry south of Fort William drive to Lochaline and then by ferry to Fishnish.

WHERE TO STAY
Kinloch Hotel, tel: +44 (0) 1681 704204, occupies a fantastic location on the main road (A849) to Fionnphort. Other ideas can be found at www.holidaymull.org or contact the Scottish Tourist Board, details on page 190.

WHAT TO SHOOT
Spectacular landscapes both on Mull and across to the mainland, superb variety of animal and bird life such as otters, seals, herons and buzzards. Try close-ups of shells on the beach or flora.

WHAT TO TAKE
Clothes for all conditions. Strong insect repellent. Binoculars and/or spotting scope if you want to make that sea eagle more than a dot.

BEST TIME OF DAY
For the best light it has to be early morning or late evening. If you want to see otters wait till it's calm and look for conspicuous trails appearing on the surface of the lochs.

ORDNANCE SURVEY MAP
Landranger sheet 48

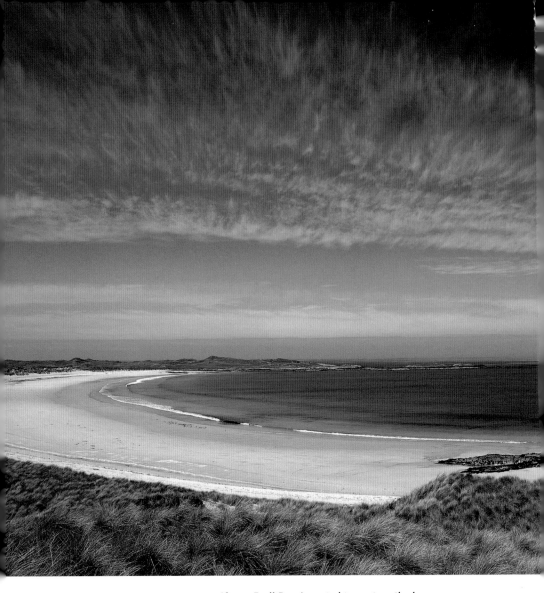

Above Feall Bay. I wanted to capture the key
elements of the Coll landscape – machair grassland
in the foreground with white shell sand set against the
blue tones of sea and sky. I used a polarizer to bring
out the colours further.

*Pentax 645NII with 45–85mm lens, 1/10sec at f/16,
Velvia 50, polarizer, tripod*

Coll

WITH LONG STRETCHES OF WHITE SAND, TURQUOISE SEA AND CARPETS OF WILD ORCHIDS, COLL IS AN IDYLLIC PLACE TO ESCAPE EVERYDAY LIFE **LIZZIE SHEPHERD**

Stretches of white sandy beaches, turquoise blue waters, carpets of wild orchids, basking sharks breaching just beyond the surf – and the elusive corncrake. This is just a taste of what you may find if you visit Coll – a beautiful and unspoilt island off the west coast of Scotland.

Feall Bay seemed to leap out as one of the first places to visit. We approached from the east, walking along paths leading us through the machair grassland. Our first view of the bay was from above, looking down on a wide crescent of white sand and crystal-clear waters that wouldn't have looked out of place in the Caribbean.

There are those that say you should only take photographs early or late in the day during summer, because this is when you get the best light. However, I have found that beach scenes such as these often have the greatest impact when photographed nearer the middle of the day. This shot was taken late in the morning and I believe the midday light brings out the intense colours even more that the softer evening light. We're lucky in this country to get amazing light at any time of day.

The rest of our time on the island was spent exploring on foot, bicycle and by car, photographing a combination of beaches, birds and wild flowers – in particular an amazing array of marsh and heath orchids. A later visit to Feall Bay in the early evening brought us a superb sighting of a basking shark, trawling for plankton just beyond the surf. We saw many sharks during our visit, but to get so close on this occasion was quite amazing.

Left Yellow flag irises grow along the quiet Coll roads – I had been unable to fit my tripod in my bike bag. I braced myself as much as possible and focused on the middle of the irises to ensure a sharp foreground while still allowing reasonable depth of field in the distance.

Pentax 645NII with 45–85mm lens, 1/90sec at f/11, Velvia 50

Coll

The small Hebridean island of Coll is about 12 miles (20km) long and only 3.7 miles (6km) at its widest. Its waters are inhabited by minke whale, dolphin and basking sharks. Coll, with neighbouring Tiree, has the second largest area of machair in Scotland. Machair is a Gaelic word describing a sandy coastal grassland and is one of the rarest habitat types in Europe, vital in both ecological and conservational terms. It is home to many rare carpet flowers and breeding birds – not least the corncrake. This protected bird is present from mid-April to September and while it is easy to hear, seeing one is extremely difficult! In such an environment it is of course important to be careful about where you walk, to ensure you don't add to the ever-increasing threat of erosion.

PLANNING

LOCATION
Coll is 8 miles (13km) west of the Island of Mull and 46 miles (74km) north-west of Oban.

HOW TO GET THERE
By ferry with Caledonian MacBrayne, tel: +44 (0) 8705 650000, www.calmac.co.uk, from Oban which can be reached by road or rail. Alternatively, by boat and taxi from the small airport on the neighbouring island of Tiree, with a flight from Glasgow.

WHERE TO STAY
The Coll Hotel, Arinagour, tel: + 44 (0) 1879 230334, www.collhotel.co.uk, is particularly recommended. For other ideas try visiting www.isleofcoll.org or contact the Scottish Tourist Board, details on page 190.

WHAT TO SHOOT
Beaches, sand dunes, wild flowers, basking sharks, minke whales, dolphins, otters, bird species including corncrakes in early summer and barnacle geese in the winter.

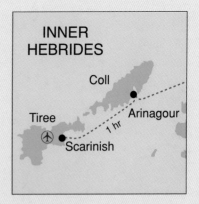

WHAT TO TAKE
Wideangle lens to capture the extensive beaches, telephoto for flora and fauna and ideally a low tripod for flower shots, wetsuit.

BEST TIME OF DAY
Early or late in the day is best for wildlife; the early evening light is particularly beautiful in summer but don't discount the middle of the day for intense colours.

BEST TIMES OF YEAR
Winter to enjoy the island at its quietest and it should be excellent for birds – the RSPB site lists both barnacle and Greenland white-fronted geese as winter visitors.

ORDNANCE SURVEY MAP
Landranger sheet 46

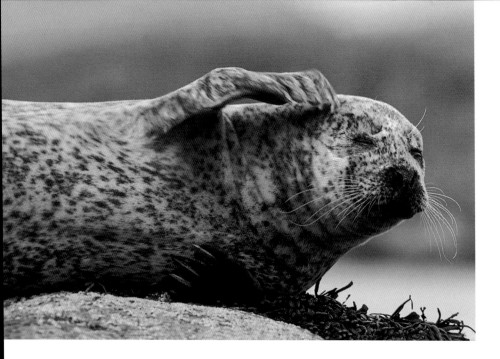

ISLAY, WITH ITS RICH FARMLANDS AND AMPLE PEAT RESERVES,
IS FAMED FOR ITS FINE MALT WHISKY PRODUCTION AND IS A
HAVEN FOR MIGRATORY BIRDS **NIALL BENVIE**

I first travelled to Islay in 1984, inspired by Michael
Warren who wrote an account of a visit in his book,
Shorelines, to accompany his paintings. Like a host of
other birders and photographers, I have returned on
numerous occasions, drawn back by the mix of the
pastoral and the wild. Islay is home to the UK's first
commercial power station using wave energy, which
feeds power into the National Grid. The engineers
could scarcely have chosen a better location; the
waves that ram into Islay's west coast are an awful
sight when pursued by a ferocious westerly wind.

On this occasion, we travelled along the back of
Saligo Bay towards the ramparts of Rubha Lamanais.
Saligo has been subject to spectacular geological
traumas, as evidenced by its contorted rocks which
are under daily assault from the Atlantic.

Islay

Left Along the coastline it is possible, with patience, to get close to common seals. Here I spent half an hour slithering over rocks until I was within range.
Nikon F4 with 300mm lens and 1.4x converter, 1/125sec at f/4, Sensia 100, beanbag

Islay

The combination of pure water, ample peat reserves and long tradition have made Islay a centre of malt whisky production, although most of the best known labels are now owned by multinationals. Although the pastures are fertile, raising cattle is still expensive relative to the mainland and the depression of the beef market has been felt hard here. During such times of agricultural recession, the priorities of conservationists on the island are not always in line with those of farmers.

Under certain conditions, rafts of spume accumulate on the shore near the river mouth. We headed for the northern end simply because it offered the most extravagant geology, with the colourful bonus of xanthoria-encrusted rocks.

With the sun now lowered behind some vapid clouds near the horizon, the low red light striking the ramparts, which I had hoped for, didn't materialize. I used a flash to illuminate some brightly coloured foreground. Looking at the rest of the scene I noticed that the waves stood out well from the abysmally dark sea. I reasoned that I could get away with underexposing the scene and using the relief provided by the whitecaps to break up the dark space. Flash was to make a bigger contribution than in a simple fill-in situation so, with daylight exposure set to underexpose the scene by one stop, I dialled the flash exposure compensation to –1EV, rather than the normal –1.7EV, for fill. For good measure, the sky was held back further with a two-stop hard neutral-density graduated filter.

Expert Advice
The landscape of Islay favours many species of birds, notably barnacle and Greenland white-fronted geese, and supports unusually high numbers of brown hares. I also think of Islay as the Isle of Fences – there always seems to be one in the way when I want to shoot from my van.

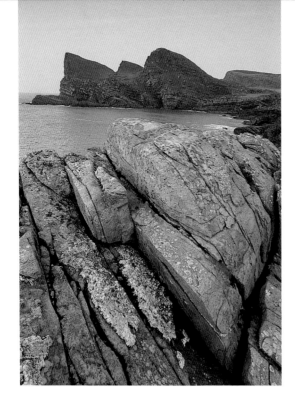

Left Rubha Lamanais. I tried to compensate for poor light with a shapely composition, exaggerating the angles of the rocks. *Nikon F4 with 20mm lens, exposure details not recorded, Velvia 50, 2-stop neutral-density graduated filter*

Right The low red light striking the ramparts, which I had hoped for, didn't materialize so I used a flash to illuminate some brightly coloured foreground. *Technical details not recorded*

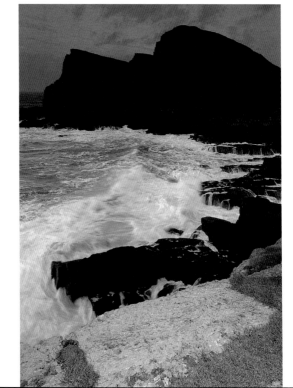

PLANNING

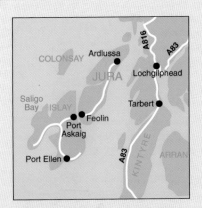

LOCATION

Islay is in the southern Hebrides, on a similar latitude to Glasgow. Rubha Lamanais is at the north end of Saligo Bay, on the west coast. The ferry crossing from the mainland takes about two hours.

HOW TO GET THERE

The Caladonian MacBrayne ferry, tel: +44 (0) 8705 650000, www.calmac.co.uk, sails out of Kennacraig, just off the A83 for Campbeltown. There are also scheduled British Airways flights from Glasgow and it is possible to hire a car at the airport which lies between Bowmore and Port Ellen.

WHERE TO STAY

I normally use a campervan which saves disturbing B&B hosts at unsociable hours. For full listings go to www.visitscottishheartlands.com or contact the Scottish Tourist Board, details on page 190.

WHAT TO SHOOT

The geese and hares may be relatively approachable but you'll have to put in some work to have any success with choughs and ravens (and most likely a licence from SNH if it is during the breeding season). The neighbouring island of Jura offers some great opportunities to photograph red deer and wild goats, as well as spectacular scenery.

WHAT TO TAKE

Usual photographic equipment, neutral-density graduated filters can be useful.

BEST TIMES OF YEAR

Islay is interesting at any time of year, but in spring the hares are more active and the geese are still around, although in smaller numbers than in October/November.

ORDNANCE SURVEY MAP

Landranger sheet 60

Contributors

ALLAN DEVLIN is a freelance photographer working mainly on landscapes and events. He manages a photo library, South West Images Scotland, devoted to this beautiful region of Scotland.

ANDREW LINSCOTT'S photographic interest was ignited by landscape and wildlife shots. Since starting his own business in 1997, he has added commercial and industrial work to his portfolio.

ANDREW PARKINSON has been a full-time wildlife photographer since 2001. His work has been featured in *BBC Wildlife*, *Global*, *Mammals UK* and he has recently appeared on television in *Wild About Wales*.

ANDY LATHAM is a landscape enthusiast and regular contributor to *Outdoor Photography*. He won the title of *Practical Photography* Photographer of the Year in 2004.

COLIN VARNDELL is a wildlife and stock photographer whose work has featured in countless magazines and publications. He love of wildlife, foxes in particular, drew him into photography from a career in construction.

DAVID DALZIEL'S passion for photography began when he started climbing munros in the Highlands and wanted to capture the beauty of the landscape. He also enjoys photographing the grand cities of Edinburgh and Glasgow.

DAVID WARD specializes in large-format photography and particularly loves landscape work. His clients include many from the world of advertising, design and publishing. He is the author of *Landscape Within* (Argentum Press, 2004) and has contributed to many UK travel guides.

DAVID TOLLIDAY'S work has featured in a range of leaflets and publications for the RSPB. He regularly presents slide shows to natural history societies and camera clubs and specializes in British wildlife.

DENNIS HARDLEY, professional photographer for 35 years, has built up a 30,000-strong image library of Scotland. He has contributed to countless magazines, calandars and has published six books on Scottish scenery.

DUNCAN MCEWAN enjoys photography that captures all aspects of Scotland and Scottish life. He lectures and judges across the UK and conducts landscape workshops in Scotland.

GUY EDWARDES is a professional nature and landscape photographer whose work has been widely published by national and international clients. His first book is *100 Ways to Take Better Landscape Photographs* (David & Charles, 2005).

HARRY HALL became a freelance photographer after twenty years of teaching graphics, and is now studying for an MA in Photography. He specializes in mountain and landscape work and is a fellow of the Royal Photographic Society.

IAN CAMERON set up his company, Transient Light, in 2004 but has been dedicated to photography for 20 years. A love of the Scottish landscape prompted a move from his native Kent to Moray seven years ago.

JOHN CARROLL, freelance photographer, is passionate about the landscapes of the Highlands; but is equally inspired by wandering around his local city of Glasgow, in particular the River Clyde area.

KEITH ROBESON has an intimate knowledge of the Scottish Borders having lived there all his life and working as a Countryside Ranger since 1986. He particularly enjoys landscape work and experimenting with low-light photography.

KYRIAKOS KALORKOTI is a Senior Lecturer in Information at the University of Edinburgh. Much of his spare time is taken up by landscape photography, for which he enjoys using large-format.

LIZZIE SHEPHERD, a former project manager, has recently turned to freelance photography and has had work published in *Outdoor Photography* and *Amateur Photographer*.

LYNNE EVANS, a keen photographer since 1998, recently took a six-month break from work to travel around north-west Scotland and the Western Isles whilst developing her work.

MARK HAMBLIN is a partner in the travel company Wildshots Photographic Adventures, which specializes in holidays and workshops in the Scottish Highlands, and is the author of two books.

NIALL BENVIE is a professional photographer and prolific writer on nature, with a particular interest in Scottish wildlife and landscapes. His work has featured in a huge range of magazines, newspapers and he has written three books.

PAUL GREEN has a varied background in agriculture, landscape design and construction, and is based in the Cotswolds. He is a regular contributor to *Outdoor Photography* and has had work featured in the *Pentax User Magazine* and *Wildlife Trust Magazine*.

PETER CAIRNS is a wildlife photographer who draws inspiration mainly from species and landscapes close to his home in the Highlands. He is a partner in the company Wildshots Photographic Adventures with Mark Hamblin.

PHILIP HAWKINS, a freelance photographer with a background in Scottish tourism, now specializes in capturing Scottish landscapes and historical sites. His work has featured in many publications including *Scottish Memories Magazine* and *Scottish Home and Country*.

SIMON POWIS is a lecturer at the University of St Andrews in Scotland. His main photographic interest is to portray Scottish landscape in unique lighting conditions, which he captures on both digital SLR and medium-format film.

STAN FARROW, a freelance photographer, started exhibiting his work 20 years ago and particularly enjoys capturing the changing light of the Scottish countryside in Fife.

STEVE AUSTIN is represented by several major photo libraries and his images have featured in many books, leaflets, calendars and cards. His interest in wildlife also takes on a practical aspect working as a bat adviser and mammal surveyor.

SUE SCOTT is a marine biologist and photographer based in Wester Ross. She specializes in underwater photography and has a large collection of images especially from temperate Scottish marine and freshwater habitats.

GENERAL INFORMATION ON PLACES TO VISIT AND ACCOMMODATION:

Highlands of Scotland Tourist Board
www.visithighlands.com

National Trust for Scotland
www.nts.org.uk
information@nts.org.uk
tel: +44 (0) 1312 439300

Ordnance Survey
www.ordnancesurvey.co.uk

Scottish Natural Heritage
www.snh.org.uk
enquiries@snh.gov.uk
tel: +44 (0) 1314 474784

Scottish Tourist Board
www.visitscotland.com
National accommodation booking line
tel: 0845 22 55 121
or +44 1506 832121 from outside
the UK

Scottish Wildlife Trust
www.swt.org.uk
tel: +44 (0) 1313 127765

Undiscovered Scotland
www.undiscoveredscotland.co.uk

PHOTOGRAPHIC HOLIDAYS AND COURSES IN SCOTLAND:

Photo Adventures
www.photoadventures.co.uk
info@photoadventures.co.uk
tel: +44 (0) 1665 830834

Photograph Scotland
www.photographscotland.com
tel: +44 (0) 1877 382613

Skye in Focus
www.skyeinfocus.co.uk
steve@skyeinfocus.co.uk
tel: +44 (0) 1471 822264

Wildshots Photographic Adventures
www.wildshots.co.uk
info@wildshots.co.uk
tel: +44 (0) 1540 651352

Page numbers that include illustrations are shown in **bold**.

Index

Contact us for a complete catalogue, or visit our website.
PIP, Castle Place, 166 High Street, Lewes, East Sussex BN7 1XU, United Kingdom
Tel: 01273 488005 Fax: 01273 402866
www.pipress.com